Psycho-cosmic Symbolism
of the Buddhist Stūpa

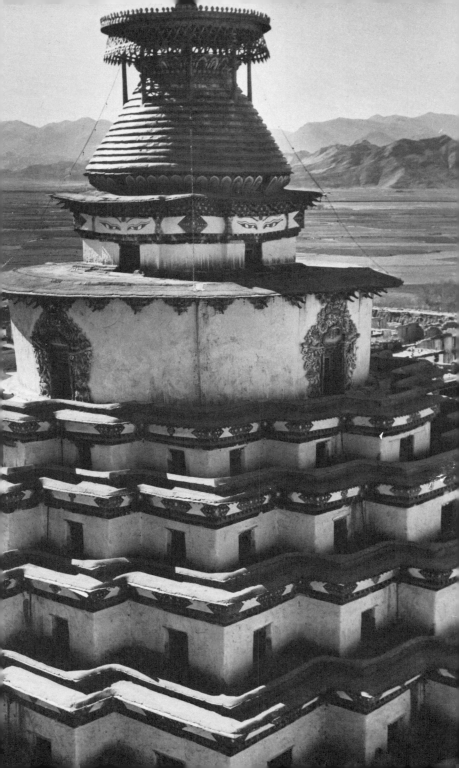

Psycho-cosmic Symbolism of the Buddhist Stūpa

Lama Anagarika Govinda

DHARMA PUBLISHING

Frontispiece: The Kum-Bum Stupa (Gyantse,
Central Tibet). Photo: Anila Li Gotami Govinda

ISBN: 0–913546–35–6; 0–913546–36–4 (pbk)
Library of Congress Catalog Card Number: 76–797

Typeset in Fototronic Janson and printed by
Dharma Press, Emeryville, California
9 8 7 6 5 4 3 2

*Dedicated
to
Tarthang Tulku Rinpoche
Founder of
the Tibetan Nyingma
Meditation Center
and
the Nyingma Institute
in
Berkeley, California*

Contents

71398

Preface to the First Edition

Anagarika B. Govinda had delivered
a course of lectures on the Stupa
Symbolism at Santiniketan
under the auspices of the International
Buddhist University Association
and I take this opportunity to thank
him for these thoughtful discourses
which I hope will be appreciated
by a larger public

Rabindranath Tagore

12/3/35

Santiniketan

Foreword

The stūpa is a very important symbol in Buddhism, especially in Vajrayāna. According to the Tibetan tradition, the stūpa has many levels of meaning. It signifies the eight events in the Buddha's life and his eight different manifestations. On the deepest level the stūpa is symbolic of the Dharmakāya. It is said that as long as these symbols of Buddhist teachings remain on this earth, the Dharma will be preserved.

Before this time, there has been very little material available on the stupa. So this small book is an important contribution. My good friend, Lama Govinda, has graciously offered this book as a gift to aid our work in the Dharma. Much of the research for the book he compiled some years ago, and I have recently conferred with him on additional Tibetan sources.

There is very great merit in making this book available and it is my hope that with this accumulation of positive actions all sentient beings may be relieved from their confusion and frustration.

TARTHANG TULKU RINPOCHE

Introduction

In the early twenties of this century I had been engaged in archaeological research in the Mediterranean and in northern Africa, thanks to a scholarship from the German Archaeological Institute in Rome. My special interest was centered on neolithic tumuli and prehistoric architecture, dedicated to the cult of the dead, a cult that conceived death not as an enemy of life, but as its other side—in fact, as that part of life, in which the spiritual qualities of man were freed from their earthly limitations, while retaining a meaningful connection with those they left behind. Thus, life and death were understood as the expression of a greater, more universal life which was shared not only by all other living beings, but equally by all that we now call the material world. Matter was still regarded as the 'mater', the motherly element, in which the spiritual forces of the universe were embodied. Therefore, all the elements of nature and all the things that were fashioned from them were approached and treated with reverence. It was this attitude that converted the material world into an animated cosmos, in which every stone, every tree, as well as waters, mountains, and clouds were alive, and all the

forces of nature emanations of divine powers. As D. H. Lawrence puts it,

> It was a vast old religion greater than anything we know:
> more starkly and nakedly religious. There is no god, no
> conception of a god. All is god. But it is not the pantheism
> we are accustomed to, which expresses itself as 'God is
> everywhere, God is in everything'. In the oldest religion
> everything was alive, not supernaturally but naturally alive.
> There were only deeper and deeper streams of life, vibra-
> tions of life more and more vast. So rocks were alive, but a
> mountain had a deeper, vaster life than a rock, and it was
> much harder for a man to bring his spirit or his energy into
> contact with the life of the mountain, as from a great
> standing well of life, than it was to come into contact with
> the rock. And he had to put forth a great religious effort.
> For the whole life effort of man was to get his life into con-
> tact with the elemental life of the cosmos, mountain-life,
> cloud-life, thunder-life, air-life, earth-life, sun-life. To
> come into immediate *felt* contact, and so to derive energy,
> power, and a dark sort of joy. This effort into sheer naked
> contact, *without an intermediary* or mediator, is the root
> meaning of religion.

Even at the Buddha's time the world was conceived as thoroughly alive and animated, as part of a universe per-vaded by consciousness and conscious beings in innumer-able visible and invisible forms. There was no place for the conception of 'dead matter'. Thus it is not surprising that the earliest Buddhist texts (and consequently all later Buddhist scriptures) admit the existence of gods, devas, and nāgas and other spiritual beings inhabiting the vast-ness of space and the depth of the earth and the sea. Ponds and springs, rivers and lakes were inhabited by nāgas, and even the treasures of the earth were protected by them.

The Buddha himself is reported to have conversed with devas and spirits inhabiting groves and other localities. In fact every place was supposed to have its *spiritus loci*. In the story of the Buddha's enlightenment it is reported that the Buddha called the spirit of the earth to witness for his repeated acts of renunciation in former lives, and that later on the Nāgarāja Mucalinda (the serpent-king) protected him from a raging storm during his meditation. And finally, after the Buddha's Parinirvāṇa, eight different tumuli (Sanskrit: stūpa) were built over his bodily remains, according to the age-old custom that had survived from neolithic times, from the very dawn of human civilization. These tumuli or stūpas gave rise to a vast architectural and spiritual tradition that has been kept alive up to the present day in all countries of Buddhist faith.

This monograph deals only with the main aspects of the developments that took place in India, Nepal, Ceylon, and Tibet. The terminology employed in the first two parts is rendered in Pāli, the language of the sacred scriptures of the Theravāda School of Buddhism, while Sanskrit has been used in the third part, which is dealing with later stūpa-forms and their psychological correspondences. The first two parts of this monograph had been subjects of lectures at Tagore's university, Visvabharati, at Santiniketan (Bengal) as well as at the University of Patna (Bihar). They were first published in the *Journal of the Indian Society of Oriental Art* (Calcutta) and later as a monograph under the auspices of the International Buddhist University Association (Sarnath & Calcutta). In the second section of Part Three some paragraphs of Part One had to be included in order to maintain and emphasize the psychological and ideological consistency in the develop-

ment from stūpa to chorten and to link up the earliest architectural elements with those of later developments in Tibet. This was all the more necessary as Part Three was published separately under the title "Solar and Lunar Symbolism in the Development of Stūpa Architecture" in 1950. It appeared in *Marg* (Bombay), a journal dedicated to art and architecture.

With the growing interest in Buddhism and its cultural and spiritual history that tends more and more to become part of an all-inclusive world culture, it is hoped that this short monograph may stimulate further interest and inquiry into the vast treasures of religious and psychological symbolism enshrined in Buddhist art and architecture. It is through the language of archetypal symbols that we reconnect ourselves with the primordial ground from which all human culture has sprung and through which we may discover our common heritage.

LAMA ANAGARIKA GOVINDA
(Anangavajra Khamsum–Wangchuk)

Tibetan Nyingma Meditation Center
Berkeley, California
July 1975

Pronunciation of Pāli
and Sanskrit Words

Vowels

The pronunciation of vowels corresponds to that of Italian or Spanish, except for the short *a* which sounds somewhat less open. There is also a marked difference between short and long vowels. The latter are marked by a line above the respective letter (*ā, ī, ū*). *O* and *e* are regarded as long vowels and, therefore, need no diacritical mark. *ṛ* is a semi-vowel, pronounced like a short *ri* with a rolled *r*.

Consonants

c corresponds to the English *ch*, like in '*church*', *ch* to *ch-h* in 'ma*tch-h*ead'. *j* corresponds to the English *j*, as in '*jar*'. *ñ* corresponds to the initial sound in '*ñ*ew', or the Spanish *ñ*, as in 'ma*ñ*ana'. *ṃ* nasalizes the preceding vowel, and is pronounced like the English *ng* in 'lo*ng*', or as the humming after-sound of *m* in the mantric seed-syllable O*ṃ*.

In all *aspirates* the *h* following the consonant is audibly pronounced. *th* should never be pronounced like the English *th*, but as two distinct sounds, like *t* and *h* in 'ra*t-h*ole. Similarly:

ph like in 'ta*p-h*ammer',
dh like in 'ma*d-h*ouse',
kh like in 'bloc*k-h*ead',
jh like in 'sle*dge-h*ammer.

The *cerebral* consonants *ṭ, ṭh, ḍ, ḍh, ṇ* require the tongue to be placed against the roof of the mouth, while in the case of *dentals* (*t, th, d, dh, n*) the tongue touches the teeth.

ś represents a sharp *palatal*, like a forceful pronounced *sh*.
ṣ is a soft *cerebral sh*.
s corresponds to a sharp *s* or *ss*, like in 'cross'.

In Indian languages the accent of a word generally lies on the long vowel (for instance *Ā'nanda, Tathā'gata, nikā'ya*). In words consisting of several syllables and short vowels, the third-last syllable carries the accent (*maṇ'ḍala; manḍa'la*, as often heard). In words of three syllables, in which the first and third syllable contain long vowels, the first syllable is accentuated (*śūn'yatā*; not *śūnya'tā*). In words of two syllables and short vowels, the first syllable is accentuated) *va'jra, dhar'ma, man'tra*, in contrast to *vidyā, mudrā*).

PART ONE

STŪPA AND DĀGOBA

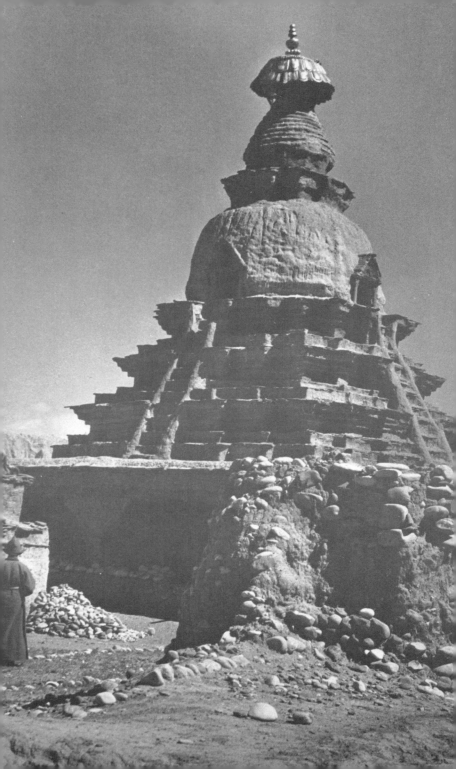

Origin of the Buddhist Stūpa

Wherever Buddhism has flourished, it has left its visible traces in the form of monuments which have their origin in the tumuli of prehistoric times. These tumuli were massive structures in the form of hemispheres, cones, pyramids, and similar plain, stereometrical bodies which contained the remains of heroes, saints, kings, or other great personalities.

In India the more or less hemispheric form, as we know it from the first Buddhist stūpas or caityas (Fig. 3), has been the prevalent type of such monuments. That they were erected for great rulers (cakkavattī) in pre-Buddhistic times according to the oldest Aryan tradition—perhaps in connection with the prehistoric nordic Kurgans—is to be seen from *Dīgha Nikāya* XVI, 5, where the Buddha mentions in his conversation with Ānanda that "at the four crossroads they erect a cairn to the king of kings."

The Buddha proclaims that the same honor should be given to the Awakened Ones and to their true disciples.

Opposite: THE GREAT STUPA OF THOLING OR LHA BAB STŪPA (WESTERN TIBET). Photo: Anila Li Gotami Govinda

As they treat the remains of a king of kings, so, Ānanda, should they treat the remains of the Tathāgata. At the four crossroads a cairn should be erected to the Tathāgata. And whosoever shall there place garlands, or perfumes, or paints, or make salutation there, or become in its presence calm in heart, that shall long be to them a profit and a joy.

The men, Ānanda, worthy of a cairn, are four in number. Which are the four?

A King of Kings (Pāli: cakkavattī; Sanskrit: cakravartin) is worthy of a cairn.

A Tathāgata, an Able Awakened One, is worthy of a cairn. One awakened for himself alone (Paccekabuddha) is worthy of a cairn, and a true hearer of the Tathāgata is worthy of a cairn.

And on account of what circumstance, Ānanda, is a Tathāgata, an Able Awakened One (or 'a Paccekabuddha', etc.) worthy of a cairn?

At the thought, Ānanda, 'This is the cairn of that Able Awakened One' (or 'This is the cairn of that Paccekabuddha', etc.), the hearts of many shall be made calm and happy; and since they had calmed and satisfied their hearts, they will be reborn after death, when the body has dissolved, in the happy realms of heaven. It is on account of this circumstance, Ānanda, that a Tathāgata, an Able Awakened One (or a Paccekabuddha, etc.) is worthy of a cairn. (Transl. by Rhys Davids in *Dialogues of the Buddha*, Vol. II.)

In this way the Buddha gives a new meaning to the stūpas. They are no longer intended to be the abodes of souls or spirits, or mere receptacles of magic substances as in prehistoric times, but memorials which should remind later generations of the great pioneers of humanity and inspire them to follow their example, to encourage them in

their own struggle for liberation, and to make their hearts 'calm and happy'.

Thus the caitya is elevated from the service of the dead to the service of the living. Its meaning does not remain centered in the particular relics, or the particular personality to whom those remains belonged, but in that higher actuality which was realized by the Holy Ones. The Buddha does not say 'a stūpa should be erected for me or for my disciples' but 'for the Awakened Ones and their disciples'.

Thus, the stūpas did not become objects of hero worship, but symbols of nibbāna, of illumination.

In this connection it may be mentioned that some of the old stūpas were covered from top to bottom with small triangular recesses for oil lamps, so that the whole monument could be illuminated and appeared as one huge, radiating dome of light.

The universality of the principle of enlightenment (bodhi) and the boundlessness of the Enlightened One who has surpassed the limits of individuality, who is deep and immeasurable like the ocean—this universality is expressed in the cosmic symbolism of the stūpa. In fact, its main element, the cupola, imitates the infinite dome of the all-embracing sky which includes both destruction and creation, death and rebirth. The early Buddhists expressed these principles by comparing the cupola of the stūpa to the water bubble and the egg (aṇḍa) as the symbol of latent creative power (as such 'aṇḍa' was also a synonym for the universe in the oldest Indian mythology), while the kiosk or altar-like structure (harmikā) which rose on the summit of the cupola (Fig. 1), symbolized the sanctuary enthroned above the world, beyond death and rebirth. Nepalese

stūpas, which in many respects have preserved archaic features, decorate the harmikā with painted human eyes, thus suggesting a human figure in the posture of meditation hidden in the stūpa: the crossed legs in the base, the body up to the shoulders in the hemisphere, the head in the harmikā. This also corresponds to the psycho-physiological doctrine of the cakras or centers of psychic force, which are located one above the other in the human body and through which consciousness develops in ascending order: from the experience of material sense-objects through that of the immaterial worlds of pure mental objects, up to the supramundane consciousness (lokuttaracittaṁ) of enlightenment, which has its base in the crown cakra of the head (sahasrāra cakra). The latter would correspond to the harmikā.

The symbolism proceeds in two lines, the cosmic and the psychic; these find their synthesis in the psycho-image of man, in which the physical elements and laws of nature and their spiritual counterparts, the different world planes (loka), and their corresponding stages of consciousness (lokiya cittāni) as well as that which transcends them (lokuttara-cittaṁ) have their place. That such ideas go back to the earliest periods of Indian history can be seen from representations of the Jain world system in the shape of a human figure.

The altar-shaped harmikā on the summit of the cupola was crowned by one or more honorific umbrellas of stone and served, in accordance with its symbolical importance, as a receptacle of relics; in pre-Buddhistic times these were buried most probably in or under the massive and more or less flattened stone hemisphere or its (round) terrace-like base if one existed. The resemblance of the harmikā to a

sacrificial altar is perhaps not unintentional, because the Holy One, instead of sacrificing other beings, sacrifices himself to the world. As the Buddha teaches: There is only one sacrifice which is of real value, the sacrifice of our own desires, our own 'self'.[1] The ultimate form of such a sacrifice is that of a Bodhisattva who renounces even nirvāṇa until he has helped his fellow-beings to find the path of liberation.

From the standpoint of the sacrificial altar, the later idea, which compares the harmikā with the element of fire, gets a new significance. Even the eyes on the harmikā of Nepalese stūpas fit into this symbolism, because according to the Tantras, fire (agni) corresponds to the eye (faculty of vision, also of inner vision).

The stūpas were surrounded by great stone fences (vedikā) originally made of wood, as their architectural character indicates, separating the sacred place from the profane world. Most of them were decorated with auspicious signs in order to ward off evil influences and to prepare the minds of the worshippers before entering the sanctuary. Four beautifully carved gates (toraṇa), the climax of the decorations of the fence, opened towards the

1. In the *Kūṭadanta Sutta, Dīgha Nikāya* I, 5, the Buddha discusses the value of sacrifice with a Brahmin who holds the view that there cannot be religion without sacrifice. The Buddha does not deny this, but while rejecting the bloody brahmanical sacrifices, he shows in their place a number of higher sacrifices, each better than the previous one, and finally, he explains the best and highest of all, the sacrifice of one's own selfish passions (āsava) in the attainment of sainthood. "This, O Brahmin, is a sacrifice less difficult and less troublesome, of greater fruit and greater advantage than the previous sacrifices. And there is no sacrifice man can celebrate, O Brahmin, higher and sweeter than this."

four quarters of the world, emphasizing the universal spirit of the Buddha-Dharma, which invites all beings with the call: "Come and see!" The inner space, between the fence and the stūpa, and the circular terrace (medhi) at the basis of the cupola were used (as pradakṣinā patha) for ritualistic circumambulation in the direction of the sun's course. The orientation of the gates equally corresponds to the sun's course, to sunrise, zenith, sunset, and nadir. As the sun illuminates the physical world, so does the Buddha illuminate the spiritual world. The eastern toraṇa represents his birth (buddha-jati), the southern his enlightenment (sambodhi), the western his 'setting in motion the wheel of the law' (dhammacakkapavattana) or the proclamation of his doctrine, and the northern his final liberation (parinibbāna).

The entrances were built in such a way that they appear in the groundplan as the four arms of a swastika (Fig. 2), which has its center in the relic shrine on the top of the hemisphere. In other words, in place of the cosmic center, which, according to ancient Indian ideas, was Mount Meru with the tree of divine life and knowledge (in Buddhism, the Bodhi tree), there stood the Buddha, the Fully Enlightened One, who realized that knowledge in his own life.

Stages in the Development of the Stūpa in India and Ceylon

It is interesting to see how closely the architectural development of the stūpa follows the spiritual growth of the Buddha-Dharma. The early schools of Buddhism are mainly realistic. They are still under the influence of the historical personality of the Buddha. The fact that he lived in this world as a human being and attained his aim in this earthly life is still in the foreground and urges them to imitate his career. Their minds are directed to the practical fulfillment of his precepts and the monastic rules as given by his first disciples. The Vinaya stands in the center of their attention; to them the life here is more important than the life to come, the empirical world more actual than the worlds beyond, the objects of perception have comparatively more reality than the perceiving subject: concentration and pacification of the mind are the highest virtues.

The original elements of the stūpa speak the same language if we analyze them from the psychological point of view. The groundplan and starting principle of the stūpa is the circle, the symbol of concentration. As a three-

dimensional form the stūpa is essentially a hemisphere; it represents the principle of concentration in a higher dimension which not only coordinates the forces of one plane but creates an equilibrium of all the forces concerned, a complete relaxation of tension, the harmony of coming to rest within oneself. Every point of the surface is equally related to the center, and each gets its meaning and its importance from there, immune against external influences or disturbances, combining concentration and restfulness.

The earliest stūpas did not attain the shape of a perfect hemisphere but rather of a spheric calotte (Fig. 1) which, together with the cubic harmikā structure on its crown, produced an earth-drawn effect. The cube, by virtue of its own inherent principle of resistance, inertia, or heaviness, deprives the spheric contour of its abstract or transcendental effect, just as the early Buddhists rejected transcendental problems and metaphysical speculations, contenting themselves with the empirical world. But this was not a narrow or materialistic contentment. According to the Buddha's teaching, the empirical world does not denote a constant factor but something that grows and expands its limits according to the growth of our mind and experience. Even what we call metaphysical may come into the range of the physical and empirical. The higher jhānas, for instance, and the worlds corresponding to them are transcendental only to those who have not experienced them. For the Buddha they are part of the empirical world. His anti-metaphysical attitude is not a negation of higher realities but, quite on the contrary, an affirmation of the possibility to attain them, which would be precluded if people would content themselves with intellectual definitions and speculations.

This also shows the limits of rationalism, which has been declared the main characteristic of the early Buddhists by misinterpreting their realistic and empiric tendencies. They accepted 'reason' as a means of expression or an approach to the Dharma but never as the ultimate principle for the attainment of enlightenment.

This we have to keep in mind if we call the archaic type of stūpas realistic, empirical, or earth-drawn: the last term, especially, is to be well distinguished from earth-bound. All these terms are to be regarded as synonyms of experience, as opposed to speculation, transcendentalism, philosophic idealism, etc. The architectural relationship to the earth corresponds exactly to the spiritual connection of the Buddhist with the earth as the foundation of his experience, as the firm ground on which, ever conscious, the structure of his life and thought is erected.

While in other religions heaven or the life to come form the center of gravity, Buddhism has reinstalled life here in its legitimate rights. Man creates his own hells and his own heavens. Why then wait? Why should one not begin right now to bring down heaven into this life? Thus the true Buddhist stands with both his feet firmly planted on the earth, without a glance towards heavenly rewards and delights, solely bent upon liberation.

The bhūmisparśa-mudrā, the gesture of touching the ground which has become one of the characteristic features of Śākyamuni, the historical Buddha, is the iconographical counterpart of the archaic ('historical') type of the stūpa and the most perfect expression of 'this-sidedness' or earthliness in a new and higher sense.

Those schools which centered round the tradition of the historical Buddha naturally preserved the archaic type

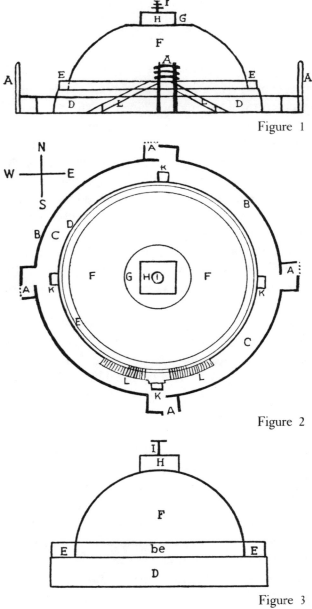

Figure 1

Figure 2

Figure 3

STŪPAS OF SANCHI

Fig. 1: Simplified ground-plan of the Great Stūpa of Sanchi (third century B.C.). Diameter of the cupola, ca. 120 feet, height 54 ft. The terrace, which was added after the completion of the cupola, is 14 ft. high and 5½ ft. wide. The next addition was the railing, of which the southern gate was erected first, then the opposite one, and finally the east-western pair.

Fig. 2: Elevation of the Great Stūpa (restored according to Sir John Marshall's plan, on which Fig. 1 is also based).

Fig. 3: Outline of a smaller Stūpa (No. 3 according to Sir J. Marshall's enumeration), about half the size of the Great Stūpa and of later origin (probably second century B.C.). The outline is not drawn to scale in order to make clear its curve in comparison with that of Fig. 1. Note the development from the flat cupola (Fig. 1) to the complete hemisphere (Fig. 3).

DETAILS:

A = toraṇa (entrance-gate).
B = vedikā (stone fence, railing).
C = pradakṣiṇā patha (circumambulatory path).
D = foundation, base.
E = medhi (terrace or upper pradakṣiṇā patha).
be = stone railing of the terrace.
F = aṇḍa (hemispheric cupola or dome).
G = terrace on top of the cupola.
H = harmikā (kiosk) in shape of a stone fence, containing the relic shrine, which in the case of the Great Stūpa consisted of a stone cylinder of ca. 6 feet in diameter. The lid of it had a hole, into which the pole of the stone umbrella was fitted.
I = htī, catta (honorific umbrella); in the ground plan indicating also the place of the cylindric relic receptacle.
K = the four main places of worship (later on: shrines).
L = staircase leading to the terrace for circumambulation.

of the stūpa; this was not only because of their conserva-
tivism, but mainly because this type of architecture was
the most adequate expression of their mentality and their
religious ideal.

It is not surprising that Ceylon as the country of Vin-
aya and as the home of one of the orthodox schools of early
Buddhism has almost perfectly preserved the original
shape of the stūpa. The monumental dāgobas of Anura-
dhapura for instance (Figs. 4–7), which were built in the
period between the third century B.C. and the third cen-
tury A.D., and even those of Polonnaruva, which are as late
as the twelfth century A.D. (Fig. 8), do not essentially
differ from their Indian prototypes in Sanchi and Barhut.
The cupola has retained its dominating importance in the
shape of a plain hemisphere: the harmikā in some cases is
even decorated in the old Indian fashion, imitating the
structure of a railing (vedikā), which originally surround-
ed the altar-like relic shrine. But the honorific umbrellas on
top of it have changed into a more architectural form.
They appear as an elongated cone with a number of hori-
zontal notches, or rings, which progressively diminish
towards the summit.

It seems that the idea of the honorific umbrellas, which
were held parallel one above the other as the insignia of
royalty, had been fused with the idea of the tree of life on
the summit of Mount Meru or the tree of enlightenment
which stands in the corresponding center of the Buddhist
world. In fact, the latter idea seems to have overgrown
finally the first one, for in later times the honorific um-
brella was actually fixed above the cone, thus showing that
the cone was not regarded as a set of umbrellas. Further-

more, it is explained in later scriptures that the different strata of the cone correspond to certain psychic faculties or stages of consciousness on the way to enlightenment and to their respective world-planes. This goes well with the symbol of the world-tree on the axis of the universe, representing the higher worlds which spread one above the other in innumerable planes beyond the summit of the sacred Meru like the branches of a gigantic tree.

The relation between the hemisphere and the socle has become closer. The substructure is no longer sharply separated from the cupola so as to form a terrace for circumambulation, but it is composed of several (generally three) projecting rings, each a little narrower than the lower one. In this way the continuity of the general outline of the stūpa is not interrupted all at once; rather, the dynamic power of the main curve is gradually broken in the 'cascades' of the socle and finally arrested in the basic step. The basis has lost its independent importance and has become part of the greater body of the dome.

Railings (vedikā) of the Sanchi type have not been preserved in Ceylon, though there was a kind of enclosure or demarcation of the sacred place around the monument serving as a circumambulatory path (pradakṣiṇā patha). The oldest stūpa of Ceylon, the Thūpārāma dāgoba, which goes back to the times of Aśoka (272–232 B.C.) has its pradakṣiṇā patha on an elevated round platform which, together with the monument, seems to have been protected by a roof. There are still two concentric rows of stone pillars, the inner ones higher than the outer ones, so that there can be hardly any doubt about their function. Even nowadays we can find 'roofed' dāgobas in Ceylon, for

instance, at Danbadeniya (westward from Polgahawela) and Gadaladeniya near Kandy. But in all these cases the dāgobas are of small dimensions. The Thūpārāma dāgoba too, according to the proportions of the stone pillars, must have been much smaller originally, and we cannot take its present shape as representative of the oldest stūpa architecture in Ceylon.

The platforms of the other old stūpas at Anuradhapura, like Mirisveti, Ruvanveli, Jetavana, Abhayagiri, etc. (which are to be dated from the second to the first century B.C.), were quadrangular, the sides corresponding to the four chief points of the compass as in the case of the toraṇas. But in place of the latter there were four small shrines or altars annexed to the base of the dāgoba. These shrines are also to be found at the main dāgobas of Polonnaruva.

The modern Sinhalese dāgoba (Fig. 9) on the whole remains true to the original character of its predecessors. The several elements of the structure, however, enter into more intimate relations with one another and merge into one organized whole. The hemisphere grows into a bell and acts as a mediator between the base and the crowning structure so that these parts enter into closer relation with its massively shaped body.

This fusion of architectural elements coincides with the progressive organization of the Buddhist doctrine and its tradition into a solid system which is worked out in many commentaries and subcommentaries, leaving no gap unfilled. The old teaching has been preserved carefully, but new layers of thought and explanatory work, not excluding scholastic speculation, have crystallized around the kernel and have given it a smoother, well-organized surface, rich in detail but simplified as a whole.

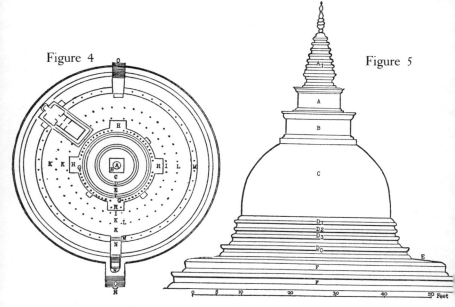

Figure 4

Figure 5

THŪPĀRĀMA DĀGOBA, ANURADHAPURA
(Third century B.C.)

Fig. 4: Groundplan, showing the original composition: a stūpa with a round platform, the four main places of worship, and the four rows of pillars accompanying the pradakṣiṇā patha.

Fig. 5: Elevation, showing the modernized shape of the stūpa or dāgoba (as it is called in Ceylon), from dhātugarbha, i.e., relic chamber, originally designating only one part of the stūpa, the receptacle in the harmikā, and later the whole building, with its tendency to subdivide or to multiply the original parts of the stūpa.

Both plans are adopted (with slight simplifications) from James G. Smither, *Architectural Remains, Anuradhapura*.

DETAILS

A_1 = spire (htī) with seven strata (bhūmi).

A = stem or base of the spire.

B = harmikā.

C = bell-shaped dome (aṇḍa).

D_1–D_3 = rudiments of the three-fold base of the archaic Anuradhapura type.

D_0 = actual base of the dāgoba proper.

E = terrace of the socle.

F = twofold socle.

G = first (inner) row of pillars.

H = main places of worship.

I = second row of pillars.

K = pradakṣiṇā patha.

L = third row of pillars.

M = fourth (outer) row of pillars, bordering the sacred place instead of the railing.

N = main entrance.

O = staircase.

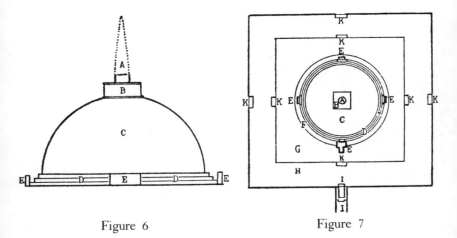

<div align="center">

Figure 6 Figure 7

RUVANVELI DĀGOBA, ANURADHAPURA
(Second–first century B.C.)

</div>

Fig. 6: Elevation (restored) showing a threefold basic terrace. The original simple base has been subdivided into three cylindric steps. The four main places of worship are strongly marked by altars and opposite entrances (in place of toraṇas).

Fig. 7: Groundplan: the platform has changed from the round to the square form, as can be seen also in the later stūpas of Sanchi. At the same time the platform has been doubled: the inner enclosure being some steps higher than the outer one. There is only a rudiment of a round platform in the shape of a circular terrace close to the base of the dāgoba. From the four chief points of the compass, steps are leading up to the platforms, the main entrance being as usual in the south, because the enlightenment, the most important of the four great events in the Buddha's life, corresponds to the sun in its highest position, i.e., in the south. The 'htī' has grown into a high cone, which probably was interrupted by several stone discs or at least crowned by one.

<div align="center">

DETAILS

</div>

A = spire ('htī'). F = circular terrace.
B = harmikā. G = upper (central) platform.
C = hemispheric cupola. H = lower (outer) platform.
D = threefold base. I = southern (main) entrance.
E = main places of worship (altars). K = steps (entrances).

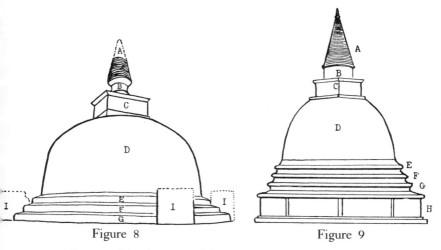

Figure 8 Figure 9

TYPES OF MEDIEVAL AND MODERN DĀGOBAS IN CEYLON

Fig. 8: Kirivehera dāgoba, Polonnaruva, twelfth century A.D. (perspectivic outline). The Anuradhapura style has been preserved, though the threefold basal terrace is higher in proportion to the dome. The main places of worship are marked by shrines.

Fig. 9: Type of a modern dāgoba. The monument proper has been put on an octagonal pedestal, isolating it from the ground (just as the religious doctrine has become isolated from experience by dogmatic tradition). The hemisphere has lost much of its monumental heaviness by growing into the more pleasing form of a bell. The threefold basal terrace is symbolized by three rings at the base of the bell. The horizontal lines of the spire are close together, forming a merely ornamental surface without interceding or crowning umbrellas.

DETAILS

A = spire ('htī'), 'kunta', Sinhalese: koṭa.
A′ = end of the spire, pinnacle, Sinhalese: koṭa kaeraella.
B = stem or base of the spire, Sinhalese: devatā kotuva.
C = harmikā, 'catussurākoṣṭha' (caturasra koṣṭha; Sinh.: hataraes kotuva.
D = cupola (aṇḍa), 'garbha'; Sinh.: gaeba.
E, F, G = in Fig. 8 the threefold basal terrace; in Fig. 9 the corresponding three rings.
H = octagonal pedestal. (trimālā) Sinh.: tun-māl pesāva.
I = shrines at the four main places of worship.

Proportions of the Dāgoba

Thūpesu tāram kṛta-pañca-bhāgam
Guṇaṁ pamāṇaṁ tribhāga-tuṅgam
Ghaṇṭākāra-ghaṭa-kāram
Bubbulākāra-dhānyakam
Padmā-kārāmbala-saṭ vidham.

Thūpesu tāram kṛta-pañca-bhāgam
Guṇaṁ pamāṇaṁ catuvīsa-bhāgam
Trimāla-pañcārdhaka-garbbham aṣṭam
Catus-surākoṣṭha-yugarddha-yugmam
Sasṭānta-kuntam puṇarddha-chatram
Vadanti cātaḥ munihiḥ purāṇaiḥ.

According to these verses which are quoted by H.
Parker, *Ancient Ceylon* (p. 336), one has to divide the
width of the stūpa into five parts. Three of them represent
the height of the cupola, which has six types: bell-shape,
waterpot-shape, bubble-shape, heap-of-paddy-shape, lo-
tus-shape, and Nelli-fruit-shape. The height of the dāgoba
is divided into 24 parts: five and a half of them are counted
for the three basal rings or 'garlands' (trimāla), eight for
the cupola (garbbha, lit. 'womb'), two and a half for the
quadrangular enclosure (catussurākoṣṭha), i.e., the har-
mikā, two for the base of the spire, the last six for the
spire, and again half a unit for the umbrella. In Parker's
opinion one and a half parts should be counted for the base

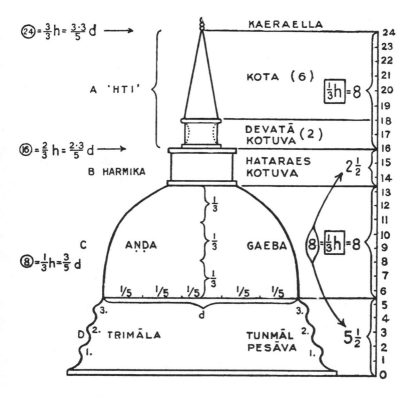

$24 = \frac{3}{3}h = \frac{3 \cdot 3}{5}d \longrightarrow$

$16 = \frac{2}{3}h = \frac{2 \cdot 3}{5}d \longrightarrow$

$8 = \frac{1}{3}h = \frac{3}{5}d$

A 'HTI'

B HARMIKA

C ANDA

D TRIMALA

KAERAELLA

KOTA (6)

$\boxed{\frac{1}{3}h} = 8$

DEVATA KOTUVA (2)

HATARAES KOTUVA

GAEBA

$8 = \boxed{\frac{1}{3}h} = 8$

$2\frac{1}{2}$

$\frac{1}{3}$

$\frac{1}{3}$

$\frac{1}{3}$

$\frac{1}{5} \quad \frac{1}{5} \quad \frac{1}{5} \quad \frac{1}{5} \quad \frac{1}{5}$

d

3. 3.

2. TRIMALA TUNMAL 2.

1. PESAVA 1.

$5\frac{1}{2}$

24
23
22
21
20
19
18
17
16
15
14
13
12
11
10
9
8
7
6
5
4
3
2
1
0

CROSS SECTION OF THE SINHALESE DĀGOBA

of the spire, because summing up all the other items, including half a unit for the chatra only, one and a half parts remain. But the verse simply mentions a 'pair' (yugmam) at this place, and the term 'sasṭānta', the 'last six', indicates that the half unit for the umbrella is an additional one (the word 'puṇa' itself emphasizes the additional character). The modern practice supports my view, as it counts two parts for the base of the spire, leaving out the umbrella, which shows that the chatra was not regarded an essential part of the dāgoba.

The main proportions of the dāgoba can be expressed in the following way: The height of the cupola, which is

three-fifths of the diameter of its groundplan, represents one-third of the height of the entire building, and is equal to the height of the spire (including its base) and to the height of the threefold base (trimāla) plus that of the harmikā.

As these proportions generally do not agree with those of the archaic Ceylonese dāgobas, the rules of the verses quoted above cannot go back to pre-Christian times, but, according to Parker, there are sufficient reasons to say that they are not later than the fifth century A.D.

Nevertheless, there is a fundamental principle which reveals itself as well in the original proportions of the stūpa as it does in the later measurements. As we can see from our summary, the key number in the vertical composition of the dāgoba is three. This is not a mere accident for it is characteristic even of the earliest Buddhist monuments. Besides the three main parts of the stūpa, namely basis, cupola, and kiosk, of which the cupola was three times the height of the basis, the railing as well as the toraṇas were formed by three bars, or architraves, of purely symbolical meaning, corresponding to the Buddhist trinity: Buddha, Dharma, Saṅgha.

The three is characteristic of the dimension of space, the four characterizes the extension on the plane, the second dimension. It appears in the groundplans as the four gates, four main places of worship, four-cornered platforms, four staircases, and finally as four- or eight-cornered substructures.

If we see the Buddha-Dharma as a spiritual building, we can find a similar tendency: to develop at the same time in two directions or dimensions which penetrate each other. The first may be called the individual, the other the

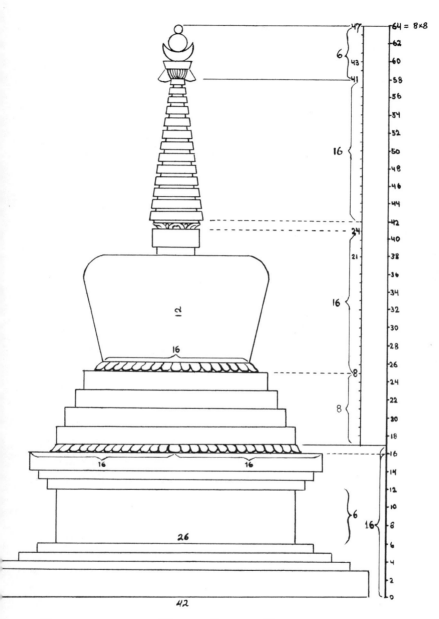

CROSS SECTION OF THE TIBETAN STŪPA OR CHORTEN

universal. Their relationship is like that of plane to space. The individual dimension corresponds to the plane, the universal dimension to space.

The individual principle is bound up with morality and ethics. It is the foundation, the spiritual groundplan on which the 'vertical' development into the next higher dimension, the universal aspect of the Dharma, is based. Just as the four is the prominent principle in the architectural groundplans of Buddhist monuments, this number prevails also among the ethical categories or individual aspects and conditions of truth in the Buddhist doctrine: as for instance, the four noble truths, the eightfold path, the four foundations of mindfulness (sati-paṭṭhāna), the four great efforts (sammappadhāna), the four fundamental (or sublime) meditations (appamaññāya: 'illimitable' state of mind), the four trances (jhāna: four in rūpa, four in arūpa), the four psychic powers (iddhipāda), etc.

The universal aspect of the Dharma, which I compared to the dimension of space, is expressed by categories in which the number three prevails in the same sense as in the vertical development or composition of Buddhist architecture. There are, for instance, three universal planes or conditions of conscious existence: kāmaloka, rūpaloka, and arūpaloka; three principles of life or universal characteristics (lakkhana): anicca, dukkha, anattā; three fundamental motives (hetu): lobha, dosa, moha (and their opposites); three principles of action (in the broadest sense): kamma, vipāka, kriyā; three principles of existence: paṭisandhi, bhavaṅga, cuti. Just as the third dimension cannot exist without the second, or an elevation apart from its groundplan, so are all these categories inseparable from the individual, and yet they go beyond it. They are uni-

versal in the sense of inherent principles or laws. Though being part of our subjective experience, they belong to the 'objective side' of life, i.e., they exist wherever life exists, while the other categories, which we called individual and ethical, are to be acquired or perceived by the individual as they do not exist in him automatically. It is only from this point of view that a distinction between 'individual' and 'universal' can be made here, but not in the sense of mutual exclusiveness. In a more general sense, any state of mind which overcomes the limits of individuality may be called universal, as for instance the 'appamaññāyas', but it is neither a constant factor of consciousness nor a universal function or principle of life.

Symbolical Terminology
of the Main Elements
of the Dāgoba

Not only the proportions but also the names of the different parts of the dāgoba as preserved by the Sinhalese tradition (cf. Parker, *Ancient Ceylon*) are of some interest to us. The decorative function to which the threefold terrace has been reduced is indicated in the Sinhalese term tun-māl pesāva or pesāvalallu, 'the three-story ornaments' or 'ornamental bangles'. The bell-shaped cupola is called gaeba, generally translated as 'chamber'. The same word is used for the holy of holies. But it means much more than that, being connected with one of the most significant terms of Indian architecture. The holy of holies, the shrine or sanctuary of Hindu temples is called garbha-gṛha, lit. womb. The sanctuary, be it the cella of a temple or the relic chamber of a stūpa, is regarded as a center of creative forces, which like those of the motherly womb generate and transform the seeds of the past into the life-forms of the future. The same function is represented by the egg

(aṇḍa), and it is not difficult to understand that both terms, aṇḍa and (dhātu-) garbha could be applied simultaneously to the stūpa-dome.

This indicates that the stūpa is the continuation of an age-old tradition which has its roots in the telluric symbolism of prehistoric, matriarchal religions, in which the creative force of the earth (soil) as the mother of all visible life was worshipped in caves, subterranean sanctuaries, or dark temple chambers. The early Buddhist cave temple (caitya-halls) may be reminiscences of these chthonic cults[2] in which the motherhood of matter and the mysteries of life and creation were the center of religious attention.

The 'dynamic materialism' of Sāṃkhya with its philosophy of Prakṛti and the 'biological materialism' of the Jains—in which even mental properties were reduced to substances which 'flow' into the soul, substances which can be mixed and separated and which act upon each other like chemical fluids or elements—are the religious and philosophical followers of the telluric tendencies or the earliest religions of humanity. Matter was regarded as a living reality—not something mechanical or opposed to spiritual forces or to consciousness. It was not by accident that the temples and monuments of old were built of huge blocks of stone, each of which was in proportion to the weight of the entire structure and represented a definite fraction of the

2. E. Diez, *Die Kunst Indiens*, emphasizes this idea (p. 182 f.), which, I think, holds good especially for the earliest cave-temples, though I am quite conscious of the fact that also other reasons came in, for instance, the necessity for those who wanted to lead a life of meditation to retire into the loneliest and most undisturbed places. The Buddha himself recommended caves for this purpose.

whole. It was not in vain that immense masses of stone were piled one upon the other, and that walls were constructed of an almost unbelievable thickness, regardless of the labor required and of mere utility or expediency; for in those days, men still knew the value of solid masses.

The historical and philosophical neighborhood of Sāṁkhya and Jainism agrees with the realistic attitude, the this-sided-ness of Buddhism and its appreciation of the cosmic qualities of matter, in the sense of being the basic state and the most fundamental function in the development of the world. The 'materia' itself contains this meaning: denoting that which is the mother of all phenomena, of all things. It is latent energy, life at rest, but full of hidden activity (like the egg, which is taken as a simile of creation). It is magic substance, endowed with the memory of the past (seed) and charged with potential forces which, though continuously radiating and influencing the surroundings, are capable of converting themselves into visible life and activity.

Matter is not only the exponent of physical forces, as apparent in the laws of gravitation, resistance, continuity, cohesion, indestructibility (though it may change its form or even its state of aggregation), and in its conformity to certain laws of growth or crystallization, but also an accumulator of spiritual forces, which are not fundamentally different from those of matter but only intensified to a higher potentiality and transformed into a higher dimension which includes the visible and the invisible, matter and space, the unconscious (i.e., that which is not yet conscious) and the conscious. There is no essential difference between matter and mind, between the outer and the inner world, between the movement of the wind and the movement of breath.

This attitude was not only preserved by the Buddhist doctrine, but it had been facilitated and developed by the idea that the elements of mind and matter are in constant flux and correlation. In the sixth chapter of *Abhidham-mattha-Sangaha* (a compendium of the Theravāda Abhi-dhamma), for instance, we see that, among the eleven qualities or principles of rūpa, the material as well as the immaterial elements are enumerated. Throughout the history of Buddhist philosophy and psychology, we find nu-merous statements indicating definite relations between elements, forms, colors, sense organs, sensations, states and properties of consciousness, world-planes, stages of medi-tation, etc.

If we can see matter from this point of view, we shall also be able to grasp the real meaning of relics and sacred objects like amulets, etc. Both are saturated with spiritual influences—the former by the nature of their own past, the latter by an intentional concentration of conscious forces upon them through the elaborate execution of their shape. In both cases it is the action that matters, the act of shaping, the concentration of consciousness, of intention, of will power, in which life is focussed on a particular unit of matter. The amulet is, so to say, an imitation of a material-ized life process. It is an abridged growth, an artificial proc-ess of reshaping certain life forms or potential moments of consciousness into the condensed form of symbols.

This applies exactly to the stūpa, which is not only a center of accumulated forces by virtue of the relics, but by virtue of its own symbolical composition as well, which reflects and reconstructs the eternal properties of the En-lightened Ones and the essence of their life. Though these eternal properties manifest themselves individually in ever new incarnations, they are supra-personal and reflect the

cosmic order. For this reason the cosmic symbolism of the pre-Buddhistic tumulus could serve the Buddhists as a starting point for their religious architecture and thus preserve one of the most venerable monuments of pre-historic civilization. "In the stūpa one of the oldest and most profound cosmic symbols has been preserved for us, a symbol that humanity has created in its remotest past and in its sacred awe before the wonders of the creative power of the world. Without Buddhism this symbol might have never come down to us" (E. Diez).

Originally the term dhātu-garbha referred only to the harmikā, which actually contained the relics (dhātu) and preserved them as precious seeds for the future of humanity. Later on the aṇḍa became identified with the dhātu-garbha; in fact, the dome, on account of successive enlargements grew in many cases beyond (above) the original relic chamber, thus including it and taking over its function: finally the whole monument was called dhātu-garbha (in Sinhalese, dāgoba, and in Burma and the neighboring countries, pagoda). That this name does justice to the fundamental character of these monuments becomes clear if we take into account all their symbolical elements: the latent creative power of the egg, in which life is condensed into the smallest unit, the womb in which these powers are transformed and developed, the sacrificial altar which effects a similar transformation through the purifying force of the fire, and the dhātus, the 'magic elements', which were not only purified by the fire of the pyre, but through the fire of self-denial, in which the Holy One consumed himself during his lifetime, nay, during innumerable lives.

Just as the Phoenix rises from the ashes, so the tree of

life and enlightenment grows out of the ashes of the sacrificial altar (harmikā; Sinhalese: hataraes kotuva, the four-sided or square enclosure), which crowns the dome, the monumental world-egg and the womb of a new world which has been fecundated by the seeds of a glorious past, receiving the dhātus, the potential elements for the spiritual rebirth of the world. The spire (Sinhalese: kota) of the dāgoba represents this tree of life with its higher worlds, which are realized in profound meditation on the way to enlightenment. Thus, the spiritual rebirth of the world starts in the mind of man and the tree of life grows out of his own heart, the center of his being, the axis of his own world. And while he experiences the different world-planes, the tree of life sprouts and develops within him and spreads its branches in ever new infinities; in fact, he himself turns into a tree of life, into a tree of enlightenment.

A lonely wanderer on a similar path, Angelus Silesius, has expressed this experience in the following verse:

> Shall the life tree free thee from death and strife,
> Thyself must turn divine a tree of life.[3]

The Sinhalese term for the stem of the spire, devatā kotuva, 'the enclosure of gods', is closely connected with the mythical Mount Meru with its tree of divine world-planes, inhabited by hierarchies of gods. How strong this tradition has been and how great its influence on the

3. Soll dich des Lebens Baum
　　befrein von Todsbeschwerden,
　So musst du selbst in Gott
　　ein Baum des Lebens werden.
"Cherubinisher Wandersmann" II, 230 (First Edition, 1675).

imagination of later generations, even in the remotest places of Indian colonization, like the Sunda Islands to the east of Java, is shown by the fact that on the island of Lombok in the park of Cakranagara there are pagodas with nine- and eleven-storied roofs and these pagodas are called Meru. But they are not at all dāgobas or stūpas, as they are without the main body, i.e., the dome and its basal terraces. They consist only in the hypertrophic spire of the dāgoba, which has been separated and developed independently as a representation of Mount Meru in the shape of the cosmic tree with nine or eleven world-planes.

PART TWO

ARCHETYPAL AND SCHOLASTIC SYMBOLISM

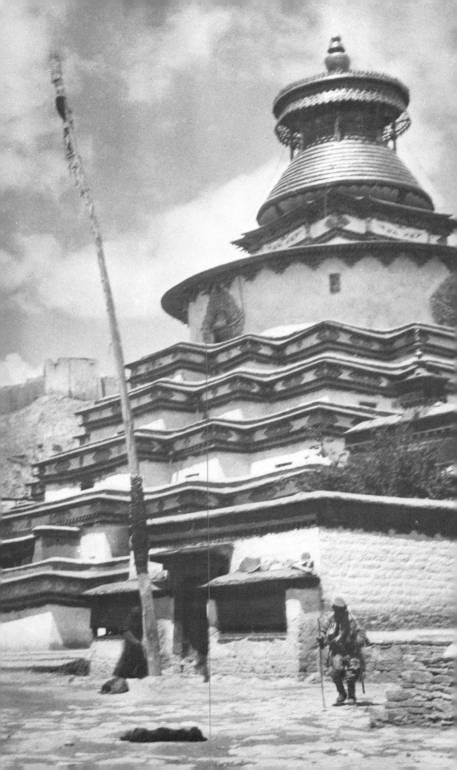

Pre-Buddhistic Origins
of Stūpa Symbolism

In Mahāyāna Buddhism the transcendental symbolism of the crowning parts of the stūpa got a new impetus. Their structure became more and more elaborate and extensive and the number of stories steadily increased from five to seven, to nine, to eleven, and finally to thirteen bhūmis. The general outline of the stūpa was no longer dominated by the dome but determined by an upward movement, which raised and multiplied the substructure, narrowed the dome, enlarged the harmikā, and elongated the spire. The direction of the religious outlook had turned from a completed past to the growing future, from the ideal of an accomplished Buddha to that of a becoming one, from the world as it is to the world as it should be and as it had been dreamt of in the vision of Mount Meru's supramundane realms. In this vision the religious aspirations of the Bud-

Opposite: THE KUM-BUM, THE TEMPLE OF THE HUNDRED THOUSAND IMAGES (GYANTSE, CENTRAL TIBET). Photo: Anila Li Gotami Govinda

dhists and the followers of the Vedas met, and only on this ground was a compromise possible. We are therefore justified in thinking that it was not a mere accident that at the time when Mahāyāna was in its bloom, in about the fifth century, a type of religious architecture came into existence which realized the spiritual and structural tendency of this vision (which was embodied in the crowning parts of the stūpa) in a parallel but otherwise independent form, developing into what is known to us as the Śikhara type of temple.

The earliest stages of this type are still wrapped in darkness. It seems that they did not originate before the Gupta period. The earliest example dating from the fifth century is a votive Śikhara temple found at Sarnath.

The village hut itself is the prototype of these shrines. And as the hut serves the earthly life, the shrine serves the cult of life-giving and life-preserving forces (generally personified in the sun-god). It stood in the shadow of the sacred tree and was surrounded by a fence as a demarcation of the sacred place. The groundplan of the shrine, like that of the altar, was almost square and the roof high, either on account of the fire or in order to distinguish it from ordinary huts. The development of pyramidal and conical forms (as in the case of the spire of the stūpa) was more or less pre-conditioned.

The temples were erected within the village, while the tumuli, which served the cult of the dead, were built outside their walls. The Buddhist stūpa which combined the elements of the village sanctuary with that of the ancient tumulus recognized in its form that life and death are only the two sides or poles of the one reality of the world,

complementing and conditioning each other, as the co-existent principles of Viṣṇu and Śiva.[1]

To think them separate is illusion, and only as long as the veil of Māyā has not been lifted, the worship of these two forces proceeds separately, sometimes even as two different forms of religion. But once it has been understood that the plant cannot be born to the light before the seed has perished in the dark womb of the earth, that the egg must break in order to give life to a new being, that transformation is that which conditions life, "that we are living our death and dying our life"—if this has been understood, then the great synthesis takes place, and the foundation of a world-religion is established. Existence is constant transformation, i.e., it combines the elements of stability and change. Transformation without constancy, law, or rhythm is destruction. Constancy without transformation means eternal death. He who wants to 'preserve' his life will lose it. He who does not find his inner law (dharma) will perish. The principle of 'Śiva' without the regulating force of 'Viṣṇu' is destruction. The principle of 'Viṣṇu' without the creative dynamics of 'Śiva' is stagnation. The same holds good for all the other pairs of opposites under which the universe appears to us. Their mutual relations and their interpenetration in every stage of existence are illustrated by the architectural composition and development of the stūpa and the ideas connected with it.

1. It must be understood, however, that while considering the principles of Śiva and Viṣṇu, we are not so much concerned with the historical aspect of architecture but with the basic tendencies of their inherent symbolism.

The hemisphere stands for the dark and motherly forces of the earth, the transforming power of death (and rebirth), the concentration of yoga and asceticism (ascetics and yogins always preferred cemeteries).

The cone as well as the similar pyramidal forms, characterized by one-pointedness and vertical direction, stand for the forces of the sun: light and life, represented by the fire-altar (harmikā) and the tree (spire). The tree later on includes all the other symbols representing the universe (Mount Meru). The sun and the stars are its fruits, and its branches the different world-planes. Tree worship has been preserved in Buddhism until the present day, the worship of light in that of Amitābha (the Buddha of infinite light, the sun-Buddha, who emanates innumerable 'enlightened beings'), the worship of life in that of Amitāyus (who is only another form of Amitābha). The idea of the Ādibuddha and his emanations shows that with the advent of Mahāyāna the symbols of the solar cult came again to the foreground.

Relations between the Stūpa and Hindu Architecture

With the revival of Brāhmaṇism Śiva became the exponent of all those principles that were connected with the hemisphere of the stūpa while Viṣṇu continues the tradition of sun worship as represented in the conical or pyramidal spire.

Śiva is called the yogin among the gods; he unites in himself asceticism and ecstasy, concentration and activity; he is the liberator, the destroyer of the world of illusion, the transformer, the creative principle (liṅgam), the potential force of the womb (therefore moon and water are his attributes).

Viṣṇu represents the law, the direction in movement, the sun that rotates and moves in its prescribed course; he is the preserver of life, the protector of the world, the illuminator who rides in his sun car (vimāna) from horizon to horizon, the loving friend and helper of all creatures (cf. avatārs). His main attribute is the wheel of the law (dharmacakra).

The south of India is mainly Śivaitic and has preserved
the dome as the crowning part of the temple. Up to the
present day the technical term for this dome or cupola is

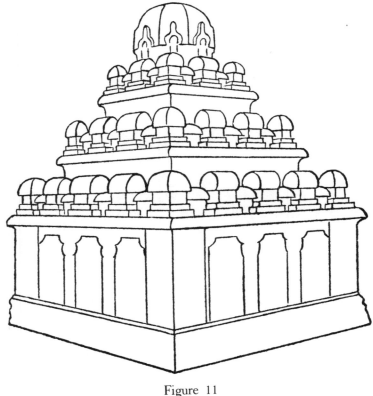

Figure 11

STŪPI-PRINCIPLE IN VIMĀNA-ARCHITECTURE

Outline of the Dharmarāja ratha in Mavalipuram as an example of
the Vimāna-type of temples, in which the cupola (stūpi) or pavilion-
principle governs the system, and in which each unit expresses cen-
tralization. In the general composition the horizontal character is
stronger than the upward movement.

'stūpi' (see drawing, Fig. 11). The north, however, which is more inclined towards Viṣṇuism, prefers the Śikhara (see drawings, Fig. 12). This fact proves that, psychologically and symbolically, the cupola is more closely related to the principle of Śiva and the Śikhara to that of Viṣṇu.

The crowning spire of a stūpa with its bhūmis or strata of world-planes corresponds in this respect to the Śikhara. In the Orissa temples (C) it is divided into five bhūmis, which are subdivided again into smaller strata (just as the bhūmis in the psycho-cosmic world system of Buddhism: there are, for instance, five rūpalokabhūmis, each of which are subdivided into three or more classes). The bhūmis culminate in the vedikā, the sacred quadrangular enclosure (Sinh. hataraes kotuva, corresponding to the harmikā and the Vedic altar), which is crowned by the āmalaka or amalasāra, the 'pure kernel', upon which the amṛtakalaśa, the vessel with the water of immortality—which is also the attribute of Buddha Amitāyus—is placed. According to the *Divyāvadāna*, the primitive caitya ended in a kind of pot, which was called kalaśa (Tucci, *Indo-Tibetica* I, p. 47, n. 1).

There can be no doubt about the symbolical inter-relationship between the Mahāyāna-Buddha Amitābha, the Buddha of infinite light (and life, in his aspect of Amitāyus), and Viṣṇu, the sun-god. Both of them are supposed to incarnate their love and compassion in the form of helpers and teachers of humanity: as Bodhisattvas and avatārs. Both of them have the wheel of the law as their attribute. The Dharmacakra is also ascribed to the historical Buddha Śākyamuni. But it was only used to represent him in his Viṣṇuitic aspect, as the establisher of the Dharma, in the act of setting in motion the wheel of the law at his first sermon at Sārnāth. The other great events of his

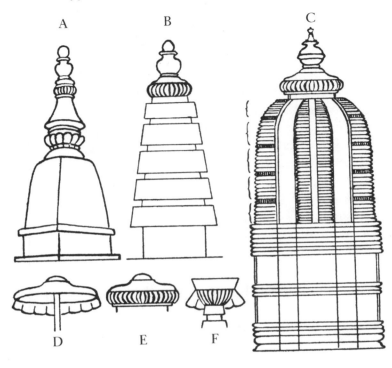

Figure 12

ARCHITECTURAL AND SYMBOLICAL RELATIONS BETWEEN THE ŚIKHARA
AND THE CROWNING PART OF THE STŪPA

Simplified elevation of an Orissa Śikhara (C) with its five bhūmis, comparable to the rūpaloka-bhūmis of the Buddhist psycho-cosmos, represented by the spire of a stūpa with tentative reconstruction of an āmalaka-kalaśa-termination (B). (A) shows a similar termination of a modern Nepalese stūpa. The combination of āmalaka and tripatadhāra (E) has been preserved in the termination of the Tibetan stūpa (mcho-rten) (F). Tripatadhāra is here replaced by an honorific umbrella from which most probably it has been derived. The shape of the tripatadhāra is exactly the same as that of the original honorific umbrella (D and upper part of E).

life, his enlightenment and his Parinirvāṇa, were hinted at by the tree of enlightenment and the caitya. This means that the historical Buddha cannot be connected exclusively with either the Viṣṇuitic or the Śivaitic aspect. He represents the one or the other according to the period of his life. The orthodox school has never given any attribute to their Buddha-image because their worship was centered on the one historical Buddha and, even when his predecessors were depicted, he could easily be recognized by his position. Later on, when other Buddhas were introduced by the Mahāyānists, Śākyamuni was characterized by the alms-bowl, the symbol of the ascetic, which shows that his quality of a yogin, his Śivaitic aspect, was felt as his main characteristic by the followers of Mahāyāna. And, in fact, the orthodox schools themselves emphasized strongly the ascetic side of Buddhism (vinaya), and in their architecture the tumulus or dome shape of the stūpa prevailed. The followers of the Mahāyāna, on the other hand, tried to avoid the exclusiveness of asceticism by taking the whole world into their scheme of salvation and emphasized the Viṣṇuitic qualities of the Buddha which transcend the historical personality and remain a permanent source of light to the world. Thus, the solar symbolism of the world tree came again into prominence, while the hemisphere of the stūpa became one element among others and the vertical development of the monument proceeded further.

Fundamental Form-principles

Before we continue our description, it may be useful to summarize the main ideas suggested by the two fundamental form-principles, hemisphere and cone: the former standing for centralization, the latter for vertical direction and one-pointedness, which may also be represented by tapering pyramids with square or polygonal base.

These two categories of principles complement each other and were never completely separated, as the history of religion and religious architecture shows. There was, on the contrary, a constant tendency towards fusion which succeeded more or less in the periods of highest religious culture and experience. But the equation Śiva-Viṣṇu was never completely solved, because there is an irrational residue beyond expression and calculation which has its root in the fact that the world cannot be divided into equal halves, because there is a third principle which takes part in the other two. In this way there are no complete contrasts—even in opposites there is something in common—and on the other hand, there is no absolute identity between anything existing in the world.

Hemisphere	Cone
lunar worship	solar worship
motherhood—earth	fatherhood—sky
symbols: moon, taurus, triśūla, yoni-liṅgam	symbols: sun, disc, wheel, lotus, tree
night (unity of integration)	day (unfoldment, differentiation)
cult of the dead	cult of life
tumulus	village sanctuary
hemisphere of the stūpa	conical or pyramidal spire
cupola, pavilions, barrel-vaulted roofs	pyramidal and conical towers with square and polygonal bases
horizontal development	vertical development
concentration	emanation
inner activity	outer activity
inner transformation	inner stability
asceticism (hermit life)	worldly or practical morality (family life)
revolution (parāvṛtti)	evolution
intuitive	discursive
yoga	pūjā
help from within	help from without
self-deliverance	deliverance by grace
belief in the divine quality of man	belief in the human quality of god
Śiva, the yogin	Viṣṇu, the solar god
the transformer	the preserver
creative (potential)	stimulative (growth)
becoming and dissolving	being
freedom (nirvāṇa)	law (karma)

The third, great principle, which partly overlaps the other two, is the Brahmā principle. Its main features are

those of extension, unfoldment, birth, manifestation, materialization, universal expansion. In its expansive character it is not determined by one direction like the Viṣṇu principle, but acts in all directions simultaneously. Its stereometrical equivalent is the cube.

We have not yet spoken of this fundamental form, because it has been combined with both of the other principles of architecture and has no deciding influence on our classification. Just as in Hindu religion, Brahmā is supposed to be inherent in the aspects of Śiva and Viṣṇu, and is not considered and worshipped separately, so the principle of Brahmā, of materialization, is immanent in the other two principles, insofar as they take material shape, come into appearance, and unfold themselves.

The Buddhist starts from the experience of the world of sense perception and frees himself from its overpowering diversity and its unsatiable thirst for 'becoming' by analyzing its elements and reducing them to their fundamental laws. He thus overcomes the Brahmā aspect of the world by the Viṣṇu aspect of the law ('dharma' in its noumenal character, 'karma' in its phenomenal appearance, in its relation to action). This struggle is the foundation of Buddhist practice, represented in the basis of the stūpa, the mass of which is reduced step by step, from its greatest unfoldment to its greatest concentration. The personality of the seeker of truth, however, with progressive understanding loses the narrowness of particularity. He becomes the embodiment of the ineluctable law of the living and yet rigid procedure of the world. And so the new aim presents itself, not only as freedom from the limitations of personality and the impulses that form and maintain it, but equally as freedom from the law of the world, which is the

world itself; for the world does not possess this law as something additional but consists in this conformity to law, i.e., in action and reaction (karma-law-cosmos-world). In this sense the Enlightened One is able to overcome the world within his own being by the annihilation of karmic tendencies (saṃskāra) and the chain of dependent origination (pratītyasamutpāda) by which nirvāṇa is realized. This is the last step from the principle of Viṣṇu to the principle of Śiva—as symbolized in the stūpa's hemisphere —the deliverance from the formed to the unformed: the ultimate transition from law to freedom. While the first stage seeks freedom in the 'cosmos'—the deliverance from becoming into being and from the undirected and indiscriminate thirst for existence, the 'chaos', to the consciously directed existence—the last stage seeks freedom from the 'cosmos'. The term 'cosmos' as used here denotes the experience of the world under the aspect of the law. Buddhism itself also belongs to the 'cosmos', that is, as far as its mental form is concerned. Only in meditation, with attainment of the arūpaloka stages, does the breaking loose from the 'cosmos' begin, and nirvāṇa lies beyond these.

But in order to be freed from the 'cosmos'—the ultimate object of suffering in the stage of the highest, most refined consciousness—one must be capable of experiencing it and must actually experience it. One must first have found his way to freedom in the law before he can attain to freedom from the law, that is, to freedom final and complete.

The Parinirvāṇa of the Buddha becomes the starting point for his followers and for the future world to traverse his 'way' again, on the basis of his noble eightfold path into which he condensed his experience. This new basis is

represented by the harmikā from which the tree of life
rises as a symbol of future attainments, fulfilling the sac-
rifice and the message of the past. The spire shows again
the gradual reduction of the world (cosmos) until it
reaches the point of complete unity which transcends all
'cosmic' experience and realizes the perfect śūnyatā or
metaphysical emptiness. The cone is crowned with a ball[2]
(kaeraella) or similar forms of the Śivaitic principle.

It goes without saying that the formal and symbolical
development in conformity with the principles of Brahmā,
Viṣṇu, and Śiva took place automatically, i.e., in accord-
ance with the inner necessities of the human psyche but
without being conscious of the originators of those monu-
ments—at least not in the earlier periods. Later on, espe-
cially among Indian Buddhist architects, these principles
may have become known to those who were initiated into
the esoteric meaning of architectural forms and meta-
physical symbolism.

In the Mānasāra the four-sided pillar is called Brahma-
kāṇḍa, the eight-sided one Viṣṇukāṇḍa, the round column
Candrakāṇḍa (candra, the moon: symbol of Śiva). This
harmonizes well with our respective classifications of the
main elements of the stūpa (though we arrived at our
conclusions in a different and safer way): the Brahmā
character of the square platform and (later on) the square
terraces of the base; the Śivaitic character of the dome; the
Viṣṇuitic character of the harmikā which, as we shall see
later on, was identified with the eightfold path. But we
have to keep in mind that in architecture the groundplans
of the different parts are not alone decisive; there is also

2. Perhaps derived from the kalaśa.

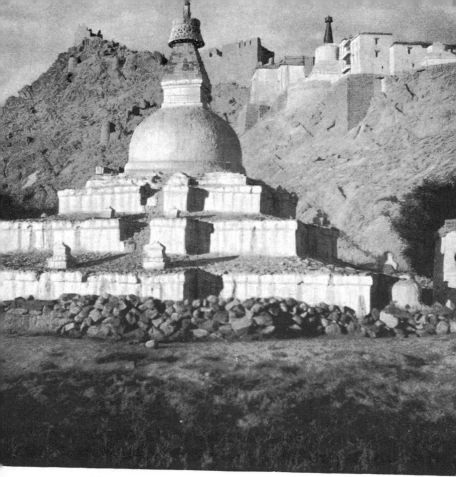

NEPALESE-TYPE STUPA IN LADAKH WITH A MODERN
TIBETAN CHORTEN IN THE BACKGROUND. Photo: Lama Govinda

their development in the third dimension and the relations
among them, which are determined by their architectural
composition and which modify their meaning. The cubical
harmikā, for instance, which starts already from the prin-
ciple of Śiva (hemisphere) cannot have the same symboli-
cal value as a cubical element in the actual basis of the
monument. The basal terraces grow narrower with every
step, which means that the Brahmā principle decreases and

gives room to another. The vertical and one-pointed tendency itself is a feature of the Viṣṇuitic principle. In the groundplan the hemisphere and the cone show the same shape, which means that they also have something in common symbolically, namely the Śivaitic principle; but in the third dimension the cone is quite different from the hemisphere, expressing a one-pointed vertical movement, which means that the Viṣṇuitic principle is combined with it. In this sense we can say that the cone itself represents the Viṣṇuitic character and that the shape of its groundplan only modifies it towards the principles of Brahmā or Śiva.

In later Buddhist symbolism the four-sided pillar is associated with the Buddha, the eight-sided with the Saṅgha, the sixteen-sided one or the round column with the Dharma. Buddha has been put in the place of Brahmā, because he is the originator, the creator of the Buddhist religion; the Saṅgha is compared with Viṣṇu, as the preserver of this doctrine; and the Dharma is compared with Śiva, because it is not the world-preserving law of god Viṣṇu, but the law that proclaims the impermanence, the suffering, and the non-substantiality of the world.

This transformed terminology is of no importance as far as our architectural definitions go and is interesting only insofar as it shows that god Viṣṇu's Dharma is not to be considered an equivalent of the term Dharma as used in Buddhism.

Scholastic Symbolism

Mahāyāna and Hīnayāna

Scholastic symbolism, though it had its origin in the philosophy and psychology of orthodox schools, existed side by side with the symbolism of later periods.

The division of Mahāyāna and Hīnayāna has probably never been so strict as some scholars believe, and, if we use these terms, we should be conscious of their limited historical meaning. They originated at Kaniṣka's famous council, where a discussion arose about the ideals of Buddhism. According to the Tripiṭaka, liberation can be attained in three ways: the way of an Arahan, that of a Paccekabuddha, and that of a Sammāsambuddha. While the Sammāsambuddha does not enter Parinibbāna before having taught to the world the Dhamma, which he has found through his own efforts in innumerable existences, the Paccekabuddha and the Arahan are realizing this Dhamma in the shortest possible way (the former independently, the latter under the guidance of a Sammāsambuddha) without possessing or cultivating the faculties of a world teacher.

It seems that originally the Arahan, the Paccekabuddha, and the Sammāsambuddha were merely classified as three types of men, while in Kaniṣka's time they were conceived as ideals, and from this point of view there could be no doubt that the ideal of a Perfect Enlightened One was the highest. It is not probable that any Buddhist school rejected this ideal, but there may have been individuals who preferred the shorter way of an Arahan either because they found it more congenial to their own temperament and character or because they thought that there was little chance of ever attaining the highest ideal. Thus, in each school of Buddhism there must have been followers of the greater (mahāyāna) as well as of the lesser (hīnayāna) ideal.

In fact, even nowadays it is a custom in the southern countries of Buddhism that all those who are earnestly interested in their religion choose one of these ideals, and most of them decide for the ideal of Buddhahood, the Bodhisattvamārga. The Mahāyāna ideal is recognized and followed even in the countries of so-called Hīnayāna Buddhism, and the terms Hīnayāna and Mahāyāna should not be used as distinctive characteristics of two separate groups or schools of Buddhism. They are distinct only in the sense of individual ideals or in the strictly historical sense of the two parties at Kaniṣka's council at which, by the way, the Theravādins, though they were later on wrongly identified with Hīnayānists, were not present. Of those who were present, only the followers of the exclusive Mahāyāna ideal have survived. The different schools should be called by the names they give to themselves, and as there are none who call their school Hīnayāna this term may be dropped altogether.

The fact that the Theravādins did not enter into the

discussion about these two ideals is not only asserted by the impartial attitude of the Pāli Tipiṭaka which leaves the choice to the individual, but also by the Kathāvatthu, the latest book of the Abhidhamma, dealing with the points of controversy with regard to the early eighteen schools of Buddhism. Among these neither the term Mahāyāna nor Hīnayāna occurs.

Where, among these eighteen schools, does the rise of the Mahāyāna enter in? The Chinese pilgrims speak of Mahāyānists and Hīnayānists, of Mahāsāṅghikas, Mahiṁsāsakas, Sarvāstivādins, and Sammitīyas, of Sthaviras, Lokottaravādins, of the Pubbasela and Aparasela Vihāras. The date assigned to Fa-Hian is about 400 A.D. The commentary, as we have it, written either by Buddhaghoṣa, or, possibly, by 'one of his school' is probably half a century later. Why are these well-known divisions in the Buddhist world omitted by the latter writer?

One thing seems fairly clear in this yet unsolved problem, namely that Fa-Hian and Yuan-Chwang, whose chronicles brought the distinction into prominence, have given the Chinese versions of the names Mahāyāna and Hīnayāna to institutions which they recognized as such, either by first-hand observation or by hearsay, institutions which in Buddhaghoṣa's school were known under quite different designations.

"The extension of the name Mahāyāna was, and is, of a vague and fluid kind. Those to whom it was applied formed no closed unit. And this is true of most of the so-called 'sects'. They frequently overlapped in their heretical views."[3]

3. C. A. F. Rhys Davids, 'Points of Controversy' (Kathā-Vatthu), pp. 45–46.

This overlapping can be observed also with regard to the symbolism of the stūpa and there to an even greater extent, as architecture is more apt to express fundamental ideas than small dogmatical differences. These fundamental ideas were those of the Abhidhamma which contains the philosophical and psychological foundation common to all schools of Buddhism, whether realistic or idealistic, empirical or metaphysical, objectivistic or subjectivistic.

In this way we find in the Tibetan Tanjur a description and explanation of the stūpa (mc'od rten)[4] in terms of the orthodox Abhidhamma, which throws a new light on the ideas that were connected with the stūpa even in pre-Mahāyāna times.

As we have seen in the case of the Ceylonese dāgobas, the socle of the stūpa which was formerly of a low, cylindrical shape had been divided into three steps to which a new basis was added later on, while the three concentric steps slowly merged into the cupola in the form of 'ornamental bangles'.

A similar process took place in the development of the Indian stūpa: the cylindric socle was first raised and later on subdivided into a number of steps, but instead of losing its independence it gained in importance by taking in the railings and toraṇas. The railings became decorative elements of the surface of the elevated substructure, and in place of the toraṇas there were staircases leading from the four quarters of the universe to the terrace on top of the socle.

The staircases, which emphasized the universal char-

4. Cf. Tucci, "Mc'od rten e Ts'a ts'a nel Tibet Indiano ed Occidentale," *Indo-Tibetica*, I.

acter of the monument, were apparently forerunners of the square basal structures, which led up to the cupola in several steps. This change coincided with the advent of Mahāyāna Buddhism and was, it seems, equally accepted by all Indian schools of Buddhism just as the universal attitude of the Mahāyāna itself.

Symbolical Meaning of the Stūpa according to the Tanjur

The symbolical meaning of the different parts of the stūpa according to the description of the Tanjur is as follows (cf. scheme, in elevation, Fig. 13, and in horizontal projection, Fig. 14):

I. The first step of the four-sided basal structure, i.e., the foundation of the whole building, corresponds to the four foundations of mindfulness (cattāri satipaṭṭhāni), namely: (1) mindfulness as regards the body (kāyānupassana satipaṭṭhānaṃ); (2) mindfulness as regards sensation (vedanānupassanā satip.); (3) mindfulness as regards the mind (cittānupassanā satip.); (4) mindfulness as regards the phenomena (dhammānupassanā satip.).

II. The second step of the four-sided basal structure corresponds to the four efforts (cattāri sammappadhānāni): (1) the effort to destroy the evil which has arisen (uppannānaṃ pāpakānaṃ pahānāya vāyāmo); (2) the effort to prevent the evil which has not yet arisen (anuppannānaṃ pāpakānaṃ anuppādāya vāyāmo); (3) the effort to produce the good which has not yet arisen (anuppannānaṃ kusalānaṃ uppādāya vāyāmo); (4) the effort to cultivate the good that has arisen (uppannānaṃ kusalānaṃ bhīyobhāvāya vāyāmo).

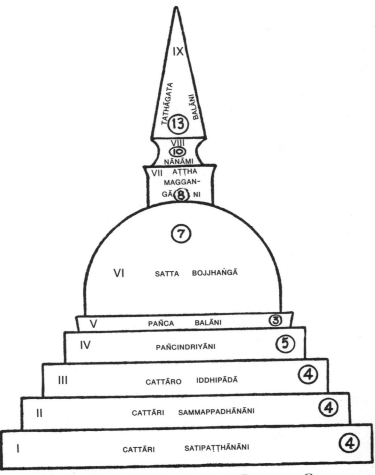

Figure 13 CROSS SECTION OF THE IDEAL DĀGOBA OR CHORTEN

III. The third step of the four-sided basal structure corresponds to the four psychic powers (cattāro iddhipādā): (1) the desire to act (chandiddhipado); (2) energy (viriyiddhipado); (3) thought (cittiddhipādo); (4) investigation (vīmaṃsiddhipādo).

IV. The fourth step or the top of the four-sided basal structure corresponds to the five faculties (pañcindriyāni): (1) the faculty of faith (saddhindriyaṃ); (2) the faculty of energy (viriyindriyaṃ); (3) the faculty of mindfulness (satindriyaṃ); (4) the faculty of concentration (samādhindriyaṃ); (5) the faculty of reason (paññindriyaṃ).

V. The circular basis of the cupola corresponds to the five forces (pañca balāni) which are of the same kind as the faculties, namely the forces of faith, energy, mindfulness, concentration, and reason. These two groups represent the passive (latent) and the active side of the same properties and they can be regarded practically as one category. The same holds good for their architectural counterparts: they were originally one element, the mediator between the cubic substructure and the hemisphere, and were split into two according to the usual tendency of later periods to subdivide or to multiply the original elements.

Obviously only the first three fourfold categories represented the original cubic basal structure and, in fact, the older types of square-terraced stūpas show only three steps, as we can see from the usual Ceylonese, Nepalese, and Burmese dāgobas and from certain Tibetan chortens which represent replicas of ancient Indian stūpas. A good example of the latter kind is a chorten built by one of the kings of Western Tibet at Sheh in the Upper Indus Valley. (See photograph, p. 49).

VI. The cupola (aṇḍa) represents the seven factors of enlightenment (satta bojjhaṅgā): (1) mindfulness (satisambojjhaṅgo); (2) discerning the truth (dhammavicāya sambojjhaṅgo); (3) energy (viriya sambojjhaṅgo); (4) rapture (pīti sambojjhaṅgo); (5) serenity (passaddhi sam-

bojjhaṅgo); (6) concentration (samādhi sambojjhaṅgo); (7) equanimity (upekkhā sambojjhaṅgo).

VII. The harmikā corresponds to the eightfold path (aṭṭha maggaṅgāni): (1) right views (sammā diṭṭhi); (2) right aspirations (sammā saṃkappo); (3) right speech (sammā vācā); (4) right action (sammā kammanto); (5) right livelihood (sammā ājīvo); (6) right effort (sammā vāyāmo); (7) right mindfulness (sammā sati); (8) right concentration (sammā samādhi).

VIII. The stem of the tree of life corresponds to the tenfold knowledge (ñāṇaṃ): (1) knowledge of the law; (2) knowledge of other persons' thoughts; (3) knowledge of relations; (4) empirical knowledge; (5) knowledge of suffering; (6) knowledge of the cause of suffering; (7) knowledge of the annihilation of suffering; (8) knowledge of the way that leads to the annihilation of suffering; (9) knowledge of the things connected with despair; (10) knowledge of the non-production of things.

Up to the harmikā or the seventh element in the construction of the stūpa, the Tanjur follows word by word the enumerations of the Pāli-Abhidhamma as found, for instance, in the third paragraph of the seventh chapter ("Samuccaya-Saṅgaha") of Anuruddha's *Abhidhammatha-Saṅgaha*. Though this work cannot have been written before the eighth century A.D., it is exclusively compiled from the canonical Abhidhamma books, and if we see a Tibetan text like the one mentioned based on a parallel Sanskrit version which does not only have the same subject matter but even the same arrangement down to the smallest detail—like the order in which the respective terms follow each other—we witness the faithfulness of tradition and the accuracy of Indian and Tibetan compilers

and translators. While Thera Anuruddha was compiling his *Abhidhammattha-Saṅgaha* in Ceylon, thousands of miles away in Tibet pious monks were translating Sanskrit texts into their own language. And though both drew their knowledge from a source that lay at least a thousand years back, their results were in almost perfect accordance! Where, however, certain differences occur, they cannot be attributed to misunderstandings but to later additions which are necessary expressions of a historical development.

In our particular case, for instance, it is characteristic that the categories representing the stūpa up to the harmikā are identical with those of the orthodox canon, while those which correspond to the tree of life show certain deviations. This indicates that the development of the more elaborate shape and symbolism of the crowning parts of the stūpa (htī) took place in later periods and under the influence of post-canonical ideas closely connected with the growth of Mahāyāna.

The deviations of the post-canonical categories can be seen by a comparison with the corresponding group, as found in the Pāli canon (*Dīgha-Nikāya* III, 33): (1) dhamme ñāṇaṃ; (2) anvaye ñāṇaṃ; (3) paricchede ñāṇaṃ; (4) sammuti ñāṇaṃ; (5) dukkhe ñāṇaṃ; (6) dukkha-samudaye ñāṇaṃ; (7) dukkha-nirodhe ñāṇaṃ; (8) magge ñāṇaṃ.

The last two items of the Tibetan classification are not contained in this group, though they may be found in other combinations (for instance as anuloma and paṭiloma paṭic-casamuppāda). More typical deviations are to be found in the next group, representing:

IX. The thirteen discs or layers of the tree of life

which correspond to the mystical powers of the Buddha. Ten of them are mentioned in *Anguttara-Nikāya, Dasaka-Nipata* xxii.

The 13 mystical powers according to the Tanjur: (1) The mystical power, consisting in the knowledge of the places which are suitable for the preaching and the activity of the Buddha; (2) the knowledge of the ripening of the different kinds of karma; (3) the knowledge of all the (states of) meditations, liberations, ecstasies, and unions with higher spheres; (4) the knowledge of the superior and inferior faculties; (5) the knowledge of the different inclinations of other beings; (6) the knowledge of the different spheres of existence; (7) the knowledge of those ways which lead to any desired end; (8) the knowledge and recollection of former existences; (9) the knowledge of the time of death and of rebirth; (10) the destruction of evil forces; (11 to 13) the three foundations of the particular mindfulness of the Buddhas (āveṇikasmṛtyupasthāna).

The 10 powers (dasa-tathāgata balāni) according to *Anguttara-Nikāya*: (1) The Enlightened One perceives what is possible as possible, and what is impossible as impossible in accordance with reality; (2) he perceives the results of actions done in the past, the present, and the future according to circumstances and causes, etc.; (3) he perceives every result, etc.; (4) he perceives the world with its different elements, etc.; (5) he perceives the inclinations of other beings, etc.; (6) he perceives the superior or inferior faculties of other beings, etc.; (7) he perceives the purity or impurity of the states of trance and of liberation, of concentration and its attainments, etc.; (8) he remembers innumerable former existences, etc.; (9) he perceives with the celestial eye—the purified, the supra-

human—how beings reappear according to their deeds, etc.; (10) by conquering his passions, he has attained, perceived, and realized by himself the passionless liberation of heart and mind, etc.

The Stūpa as Representation of the Way to Enlightenment

At first sight this scholastic symbolism will appear rather arbitrary, but if we examine it more carefully, we find that it is consistent with the constructive principles of the stūpa and their ideology. It represents the way to enlightenment, revealing the psychological structure of the Buddha-Dharma and the qualities of the Enlightened One in whom the Dharma is realized. The stūpa, accordingly, is as much a memorial for the Buddhas and saints of the past as a guide to the enlightenment of every individual and a pledge for the Buddhas to come.

As the stūpa consists of three main elements, socle, hemisphere, and crowning parts, the spiritual development also proceeds in a threefold way. The first part (foundation) contains the preparatory steps, the second one (hemisphere) the essential conditions or psychic elements of enlightenment, the third one (harmikā and tree of life) consists in its realization. Each of these main parts has again three subdivisions.

The first preparatory step is mental and analytical. Just as the foundation of the monument rests on the natural ground, the foundation of the spiritual building of Buddhism rests on the experience and analysis of nature as far as it is accessible in the psycho-physical constitution of man.

The second preparatory step is moral: morality based on insight into the nature of life.

The third preparatory step intensifies the mental and moral achievements and converts them into a psychic dynamism which arouses those latent forces which are the essential conditions or elements of enlightenment.

These elements form the static axis of the Buddhist system and occupy the central part of the stūpa: the hemisphere, its basis, and the uppermost terrace on which it rests. The fact that the latter represents the same five psychic elements as the circular basis of the hemisphere justifies its combination with the central group, though from the standpoint of architecture, it forms only the link between the original substructure and the hemisphere.

The first step of the upper triad (the harmikā) corresponds to the three steps of the substructure: it starts with right views and aspirations (sammā diṭṭhi and sammā saṃkappo) which are the outcome of the analytic knowledge (paññā) prepared in the first step; it continues with right speech, right action, and right livelihood (sammā vācā, s. kammanto, s. ājīvo), which is the fulfillment of morality (sīlaṃ); it culminates in right energy, concentration, and meditation (sammā vāyāmo, s. sati, s. samādhi) in which the dynamic forces of psyche reach their greatest potentiality.

Knowledge, morality, and concentration (paññā, sīlaṃ, samādhi) are the pillars of Buddhist practice. Morality has no meaning or value without knowledge. Therefore, knowledge is placed before morality. Concentration, on the other hand, without morality is like a house without foundation. Morality is the discipline in the outer life upon which concentration, the discipline of the inner life, is built. Morality thus has to precede concentration. Concentration again is of no value in itself; it is an instrument for the attainment of insight (vipassanā) and wisdom

(paññā), which, in its turn, produces a higher form of morality and concentration until, by this spiral-like progression (in which the same elements reappear on each higher stage in greater intensity), Bodhi or enlightenment is attained. On the first step, paññā is not more than an intellectual attitude, based on investigation and reflection (vitakkavicāra). On the corresponding step of the higher triad, it is wisdom based on the experience of meditation (inner vision), and in the last two stages it is enlightenment as the true nature of a Tathāgata. These two highest stages (represented by the stem and the 13 bhūmis of the tree of life) correspond to the factors of enlightenment (bojjhaṅgā) and to those faculties and forces which form their basis.

Parallelism of Architectural Forms and the Symbolism of Numbers

The parallelism is also obvious in the architectural forms and in the numerical composition of their elements. The groundplans of substructure, intermediate part, hemisphere, harmikā, stem, and cone of the tree of life are: square, circle, circle, square, circle, circle. Their further relations may be seen from Figure 14 and Table 1.

The fundamental functions are expressed by even numbers, the essential by odd numbers, and the mediating by even numbers (10) composed of odd halves. The intermediate parts belong essentially to the next higher elements, i.e., to the main parts of the stūpa (hemisphere and cone: stūpa and Śikhara principle). This is proved by the fact that the hemisphere includes nearly all the elements of the preceding two steps, namely viriyaṃ, sati, samādhi, and paññā (in the form of dhammavicāyaṃ), and the cone contains similar elements as the stem, namely different

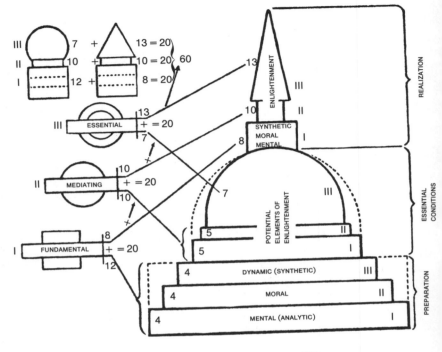

Figure 14 PROPORTIONS OF THE DĀGOBA

aspects of paññā. In the stem they are more fundamental and general, and in the cone more differentiated and specialized.

The symbolism of numbers is well developed in Buddhist philosophy, art, and architecture. The following example may suffice to give an idea of the numerical relationship between the scholastic stūpa and the co-existing psycho-cosmology. Within the three worlds (ti-loka) or main forms of consciousness (cittāni)—kāma-, rūpa-, and arūpa-loka—there are fifteen world-planes (six in kāma-, five in rūpa-, four in arūpa-loka), thirty classes of beings (ten in kāma-, sixteen in rūpa-, four in arūpa-loka, ac-

	groundplan: function:	square fundamental	circle mediating	circle essential
upper half:	formal designation: numerical designation:	harmikā 4 + 4	stem 5 + 5	cone 13
lower half:	numerical designation: formal designation:	4 + 4 + 4 substructure	5 + 5 intermediate parts	7 hemisphere
	sum of elements:	5 × 4 = 20	4 × 5 = 20	13 + 7 = 20

$$60$$

Table 1

cording to their states of consciousness), and there are sixty elements of spiritual development, as represented by the stūpa. In figures[5]:

$$3 = \text{(key-number)} \qquad = \frac{60}{20}$$

$$\text{I)} \quad 15 = 5 \times 3 \qquad\qquad = \frac{60}{4}$$

$$\text{II)} \quad 30 = 5 \times (3 + 3) \qquad = \frac{60}{2}$$

$$\text{III)} \quad 60 = 5 \times (3 + 3 + 3 + 3) = 60$$

5. Cfr. Figure 14, Proportions of the Dāgoba: The universal aspect of the Dharma which I compared to the dimension of space is expressed by categories in which the number three prevails in the same sense as in the vertical development or composition of Buddhist architecture.

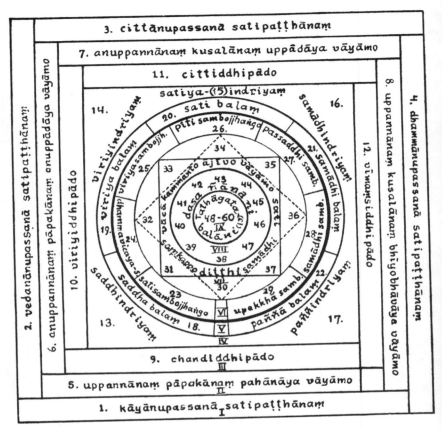

Figure 15

STAGES OF MEDITATION ACCORDING TO THE PĀLI SCRIPTURES

These sixty elements constitute a continuous way ascending through the three worlds and its different states of existence in the form of a spiral, spiritual circumambulatory path. This idea has been materialized most perfectly in the great terrace-stūpa of Barabuḍur. Though this monument belongs to the later Mahāyāna period (8th century) it can be seen from the drawing (Fig. 18) that the

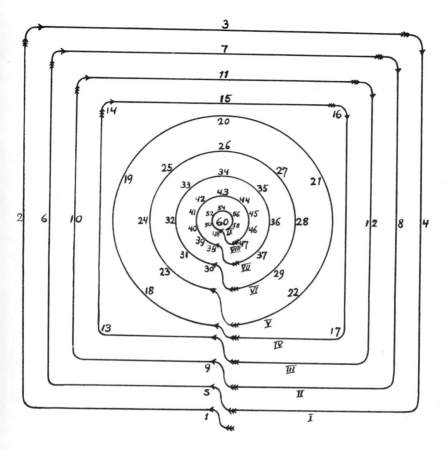

Figure 16
PATH OF THE MEDITATOR

actual groundplan of Barabuḍur fits exactly on the spiritual groundplan of the orthodox stūpa as explained by scholastic symbolism.

The same is true of the Kumbum (sKu-ḥBum), the famous terraced Chorten of Gyantse in Central Tibet, known as the Golden Temple of the Hundred Thousand Buddhas. It was built on the same general plan as that

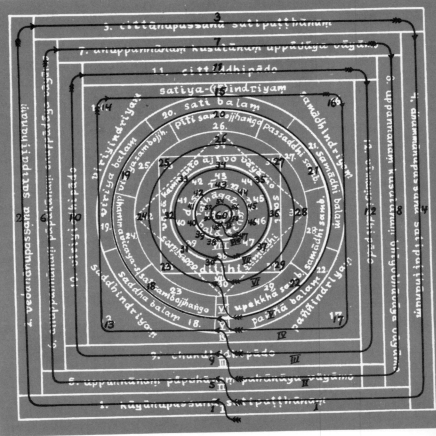

Figure 17

THE PATH OF THE MEDITATOR OVERLAYED ON THE
STAGES OF MEDITATION

which was originally intended for Barabuḍur. The latter
had to be changed in the course of its construction, because
the ground was apparently not strong enough to bear the
weight of a massive cupola, and this was further aggra-
vated by the ever-present danger of earthquakes. Thus,
in order to prevent the building from sinking, the big

Figure 18

THE PATH OF THE MEDITATOR OVERLAYED ON
THE GROUNDPLAN OF BARABUḌUR

cupola, representing the seven bojjhangas or factors of
enlightenment, had to be replaced by a circular terrace,
corresponding to the base of that cupola. The terrace was
adorned by 32 small, bell-shaped stūpas, each containing a
Buddha-statue, which could be seen through the trellised
stonework. A second and third ring of similar stūpas (24 in

the second and 16 in the third ring),[6] each ring on a higher platform with a smaller circumference, replaced the harmikā and the conical spire of the traditional stūpa, representing the noble eightfold path and the powers of higher knowledge. The final state of enlightenment was represented in Barabuḍur by the unfinished statue of the Ādibuddha, inside the central stūpa, dominating the three circular terraces. The statue was unfinished, that is, in a state between form and formlessness, as if emerging from the void, from śūnyatā. A corresponding figure in the interior of the golden spire of the Kumbum represented the Ādibuddha Vajradhāra, whose body is blue, the symbol of infinite space and of śūnyatā. The nine stories of the Kumbum correspond exactly to the nine levels of the Barabuḍur, and while the four lower terraces of the Barabuḍur are adorned with reliefs and Buddha-statues in separate niches, the four lower terraces of the Kumbum contain 80 separate chapels, containing a complete pantheon of Vajrayāna iconography in the form of statues and frescoes. Though the Kumbum was built about 500 years later than the Barabuḍur, when the latter was already buried under a deep layer of earth and forgotten even by the inhabitants of Java, the outlines of the four basic terraces of the Kumbum appear as an almost exact replica of the four lower terraces of the Barabuḍur.

Thus, we are now in a position to understand at least the fundamental ideas which were accepted by the Buddhists of all schools and which hold good even for the Burmese and Siamese pagodas of later periods, in which Mahāyāna and Theravāda meet in a new synthesis.

6. Here the symbolism of numbers is based on the 8 (eightfold path): 4 x 8 = 32, 3 x 8 = 24, 2 x 8 = 16.

PART THREE

SOLAR AND LUNAR SYMBOLISM IN THE DEVELOPMENT OF STŪPA ARCHITECTURE

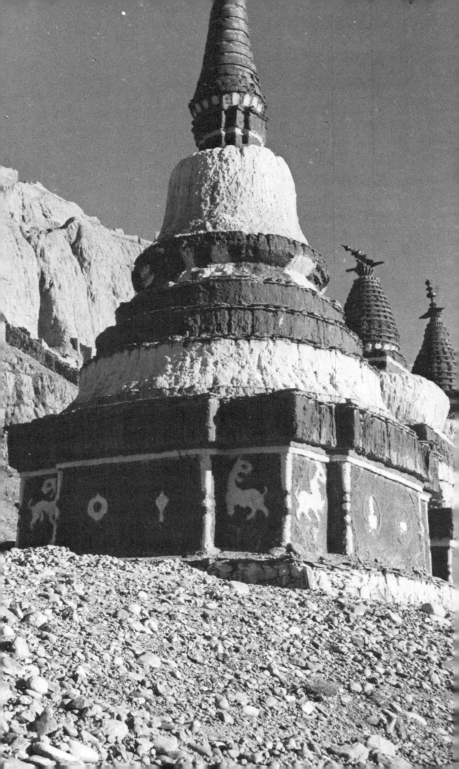

Lunar and Solar Cults
of Prehistoric Times

The life of man is governed by the rhythm of sun and moon. Sun and moon, therefore, became the first symbols under which the human mind tried to understand the universe in which man lived. They demonstrated the great polarity of forces through which the universe as well as the individual exists. All the qualities of active life were associated with the sun, the lord of the day. The moon, the ruler of the night, was associated with the hidden forces, sleeping in the dark womb of mother earth, in which germinating life is protected and nourished and into which it returns in death. The cult of the dead, and of all subterranean powers, including the waters of the depths, therefore, was associated with lunar worship. And as the earth was the motherly, so the sky was the fatherly element.

In early childhood we have a closer relationship to the mother than to the father. The same fact is repeated in the

Opposite: PARINIRVANA CHORTEN, ONE OF THE EIGHT TRADITIONAL CHORTENS (WESTERN TIBET). Photo: Lama Govinda

life of humanity; in its earliest periods it had a closer relationship to the earth and its lunar influences. The physiological relationship between motherhood and the periodicity of the moon explains the psychological relationship between matriarchy, in which the social order was based on the priority of the mother, and the prevalence of lunar worship in which the religious order (the cultural life) was based on the priority of lunar influences and their terrestrial manifestations. This does not mean that solar influences were denied but only that they were regarded as secondary, while later times reversed this attitude by emphasizing the solar influences and making them the center of religious ideology. Human civilization apparently has a tendency to move from lunar-terrestrial to solar-spatial, from matriarchal to patriarchal conceptions of life. This becomes apparent even in the methods of division of time: the lunar year has been replaced by the solar year. Only the various religious calendars, which have preserved the customs of the past, still follow the lunar year.

A similar tendency can be observed in the history of architecture, which reflects the development from the experience of mass to that of space. To the men of telluric-matriarchal civilizations who worshipped the creative forces of the Earth, matter was not a dead substance but a living reality, the mother of all things—as the word 'materia' still indicates. Consequently their sense of form (not only as a feeling for surface, but for mass and solidity) was much more developed than ours, as we can see from all works of prehistoric architecture. For the same reason we find the greatest works of sculpture not at the end but at the beginning of each civilization.

Prehistoric stone architecture, therefore, was not space-creating, or constructive, but mass-creating, or 'plastic'. In constructive architecture, space is the primary element and mass the secondary. In sculpture or monumental architecture, mass is the primary element and space only a secondary by-product. Constructive architecture serves mainly practical needs; monumental architecture, the spiritual needs of man. The constructive architecture has a utilitarian purpose, namely the creation of useful space to which the material and its structure are subordinated. The monumental or shaped architecture is an expression of the human soul, just as any other work of sculpture, which cannot be understood from a utilitarian standpoint, nor defined by principles of architectural necessity.

It is a strange fact that architecture, which according to current conception more than any other kind of art depends on matter and practical considerations, has its origin in entirely symbolical monuments which did not serve any practical purpose, but the cult of the dead. While the habitations of the living were of the most primitive and impermanent character, the dwellings of the dead were built for eternity. One would think that man tried to satisfy his material needs first, before bothering about spiritual things. But the history of humanity shows just the contrary. The practical attitude of man is a later achievement.

The same tendency can be seen in literature: poetry or metric language is earlier than prose, mythology earlier than realistic history. It seems that the nearer man was to nature the more strongly he emphasized his own being and his own creations in order to maintain himself against the threatening forces and powerful influences of the external

world. Only after the scientific exploration and domestication of these forces could man afford to open himself to nature and to look upon it objectively and dispassionately.

The mysteries of life and death were always the greatest agents of religious ritual and speculation. Through the experience of death, man becomes conscious of life. Thus, the cult of the dead stimulated primitive man to build the first great monuments (tumuli), while the other side of religious activity, which was concerned with the living and the mundane aspects of life, found expression in the simpler forms of tree and fire worship. The tumuli, originating from the burial mound, were massive structures of stone, taking the forms of hemispheres, cones, pyramids, and similar plain stereometrical bodies and containing small cells which preserved the bodily remains and other relics of heroes, saints, kings, and similar great personalities. In India, as in many other parts of Asia, the hemispheric form seems to have been the prevalent type of such monuments. According to the oldest tradition, they were erected for great rulers (cakravartin), as the Buddha himself mentions in his conversation with Ānanda (*Dīgha Nikāya* XVI, 5).

While the tumuli and the cult of the dead had their place outside the village, the sanctuary of the life-giving and life-preserving forces (personified in the sun-god) had its place in the center of the village. It consisted of a simple altar (a sanctified form of the domestic hearth, the fire of which was always regarded sacred as a symbol of family life) or a small shrine (an idealized form of the village hut) which stood in the shadow of the sacred tree (Tree of Life) and was surrounded by a fence as a demarcation of the sacred place.

The Buddhist stūpa combined the elements of the village sanctuary with the monumental dome of the ancient tumulus (cetiya), thus uniting the two oldest traditions of humanity, as expressed in the lunar and solar cult, fusing them into one universal symbol which recognized formally for the first time that life and death are only the two sides of the same reality, complementing and conditioning each other. To think of them as separate is illusion, and, only as long as the veil of Māyā has not been lifted, the worship of these two forces proceeds separately, sometimes even as two different forms of religion. But once it has been understood that there is no life without transformation and that the power of transformation is life, then the great synthesis takes place and the foundation of a world-religion is established.

The Basic Elements of the Stūpa

The Buddhist stūpa originally consisted of an almost hemispherical tumulus and an altar-like structure (harmikā) on its top, surmounted by one or several superimposed honorific umbrellas. The flattened hemisphere was compared to an egg and therefore called 'anḍa', a term which did not only allude to the shape (which was also compared to a water bubble), but to its deeper significance as well, namely, as a symbol of latent creative power, while the quadrangular harmikā on the summit of a cupola symbolized the sanctuary enthroned above the world (anḍa was also a synonym of the universe in the oldest Indian mythology) beyond death and rebirth. A similar parallelism exists between the harmikā in the shade of the multistoried, honorific umbrella and the sacrificial altar in the shade of the sacred tree, because the Holy One, whose ashes were enshrined in the altar-like sanctuary of the harmikā, instead of sacrificing other beings, had sacrificed himself for the welfare of all living things. According to the Buddha there is only one sacrifice which is of real value, the sacrifice of our own desires, our own 'self'. The ultimate

form of such a sacrifice is that of a Bodhisattva, who renounces even nirvāṇa until he has helped his fellow beings to find the path of liberation.

The honorific umbrella, finally, as an abstract imitation of the shade-giving tree—in this case of the sacred Tree of Life—is one of the chief solar symbols and, in Buddhism, that of enlightenment (sammā-sambodhi). The importance of this symbol becomes clear from the Buddhist Scriptures, which describe the struggle of the Bodhisattva and Māra, the Evil One, for the place under the Bodhi tree, which was regarded as the holiest spot in the world, the incomparable diamond throne (vajrāsana).

It must have been an old custom that the head of the community has his seat of honor under the sacred tree in the center of the settlement where public meetings used to take place on religious and other important occasions. Consequently the umbrella, which replaced the tree when the head of the community moved about or presided over similar functions in other places, later on became one of the insignia of royalty. In order to mark distinctions in rank the ceremonial umbrella was doubled or tripled or increased by even greater numbers of umbrellas which were fixed one above the other, thus transforming the umbrella back again into the original tree shape with its numerous layers of branches spreading around the stem and gradually getting shorter towards the top.

The Great Stūpa of Sanchi was crowned by a threefold honorific umbrella and the altar shrine itself was surrounded by a railing (vedikā) exactly as in the case of the village sanctuary. Similar railings were repeated at the foot of the stūpa and on the low circular terrace upon which the flattened hemisphere rested. The lowest railing was pro-

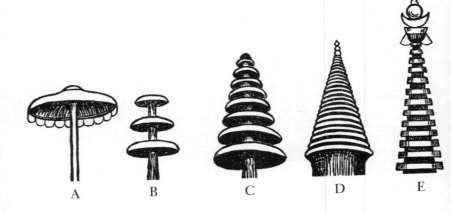

Figure 19

A: Honorific umbrella. B: Threefold umbrella of the Great Sanchi Stūpa. C: Ninefold Umbrella as Tree of Life. D: Spire of a Ceylonese Dāgoba. E: Spire of a Tibetan Chorten.

vided with four gateways (toraṇa) which opened towards the east, the south, the west, and the north, emphasizing the universal character of Buddhism which invites all mankind with the call, "Come and see!", and which exhorts its followers to open their hearts to all that lives and to radiate love, compassion, sympathy, and peace towards the four quarters of the world. The inner space between the stone railing and the stūpa, as well as the circular terrace (medhi) at the base of the cupola, were used as pradakṣinā patha for ritualistic circumambulation in the direction of the sun's course. The orientation of the gates equally corresponds to the sun's course: to sunrise, zenith, sunset, nadir. As the sun illuminates the physical world, so does the Buddha, the Enlightened One, illuminate the spiritual world. The

eastern gateway represents his birth, the southern (which was regarded as the most important and therefore built first) his enlightenment, the western his "setting in motion the Wheel of the Law" (dharma-cakra-pravartana) or the proclamation of his doctrine, and the northern his final liberation.

This universal attitude and orientation remained one of the characteristics of the stūpa especially in the northern countries of Buddhism, even after railings and gateways had disappeared. In the course of time, all these details were fused into a quadrangular substructure which finally took the form of four terraces (sometimes furnished with four staircases, if the size of the monument permitted or required them) upon which the hemisphere was raised.

As the layers of superimposed umbrellas became more numerous, they were transformed into the more architectural form of a solid cone with a corresponding number of horizontal notches, which finally amounted to thirteen. With this transformation the original idea of the Tree of Life and Enlightenment was visibly restored and steadily gained in importance. That the conical spire was no more regarded as a set of umbrellas, can be seen from the fact that later on the honorific umbrella was again fixed on top of the cone (see Fig. 19, illustration E).

Here again we see how the emphasis in the symbolism of the stūpa gradually changes from a predominantly lunar to a predominantly solar attitude. In the beginning the tumulus and the idea of the reliquary outweighed other elements of the stūpa, which in Ceylon, the most conservative of all Buddhist countries, was characteristically called 'dāgoba', which is derived from the combined term 'dhātu-garbha'. Originally this term referred only to the

harmikā, which actually contained the relics (dhātu) and preserved them as precious seeds for the future of humanity. Later on, the cupola (aṇḍa) became identical with the dhātu-garbha. In fact the dome, through successive enlargements, grew in many cases beyond and above the original relic chamber, thus including it and taking over its function, also in the material sense; finally the whole monument became the dhātu-garbha or dāgoba. (In Burma and the neighboring eastern countries this term was reversed into 'pagoda'.) That this name really does justice to the fundamental character of these monuments becomes clear if we take into account all their symbolical elements: the latent creative power of the egg, in which life is condensed into the smallest unit, the womb (garbha) in which these powers are transformed and developed, the sacrificial altar which effects a similar transformation through the purifying force of the fire, and the magic elements (dhātus), which were not only purified by the fire of the pyre, but also by the fire of self-denial, in which the Holy One consumed himself during his lifetime, nay, during innumerable lives.

And as the Phoenix rises from the ashes, so the Tree of Life and Enlightenment grows out of the ashes of the sacrificial altar (harmikā) which crowns the dome, the monumental world-egg and the womb of a new world which has been fecundated by the seeds of a glorious past, receiving the dhātus, the potential elements for the spiritual rebirth of the world. The spire of the dāgoba, pagoda, or chorten (as they are called in Tibet) represents this Tree of Life in its ideal form of the heavenly tree whose branches are the higher worlds spreading one above the other in innumerable planes beyond the summit of Mount

Meru, the axis of the universe. It is explained in later scriptures that the different strata of the cone (separated by horizontal notches) correspond to certain psychic faculties or stages of consciousness on the way to enlightenment and to their respective world-planes. Thus, the spiritual rebirth of the world starts in the mind of man, and the Tree of Life grows out of his own heart, the center of his world, and spreads into ever new infinities, into ever higher and purer realms, until it has turned into a Tree of Enlightenment.

The Psycho-cosmic Image of Man

"Verily, I tell you," the Buddha once addressed his disciples, "the world is within this six feet high body!" And on another occasion he defined the world in these words: "That in the world through which one, perceiving the world, arrives at his conception of the world—that in the Order of the Blessed One is called 'the world'" (*Saṁyutta Nikāya* IV, 35, 166).

In other words the Buddhist universe is the universe of conscious experience. The symbolism of the stūpa, therefore, can be read in the cosmic as well as in the psychic sense. Its synthesis is the psycho-cosmic image of Man, in which the physical elements and laws of nature and their spiritual counterparts, the different world-planes and their corresponding stages of consciousness, as well as that which transcends them, have their place. That such ideas go back to the earliest periods of Indian history can be seen from representations of the ancient Jain world system in the shape of a human figure.

Nepalese stūpas, which in many respects have preserved archaic features, decorate the harmikā with painted

human eyes, thus suggesting a human figure in the posture of meditation hidden in the stūpa, the crossed legs in the base, the body up to the shoulders in the hemisphere, the head in the harmikā. This also corresponds to the psycho-physiological doctrine of the centers of psychic force (cakras) which are located one above the other in the human body and through which consciousness develops in ascending order: from the experience of material sense-objects through that of the immaterial worlds of pure mental objects, up to the supramundane consciousness of enlightenment which has its base in the crown cakra of the head (sahasrāra-cakra). This cakra is symbolized by a dome-shaped or flame-like protuberance on the head of the Buddha, and by the cone-shaped Tree of Enlightenment which forms the spire of the stūpa, dāgoba, pagoda, and chorten.

The cakra itself is a sun symbol. It was one of the attributes of the sun-god, either in the form of a discus or in the form of the wheel, representing the rolling sun-chariot. The solar origin of the cakra is testified by the description of the flaming and radiating wheel-jewel (cakra-ratna), which appears in the sky with its thousand spokes (rays) when a virtuous ruler has established a reign of righteousness and has attained the spiritual power which entitles and enables him to extend the good law over the whole world and to become a world-ruler (cakravartin). Similarly, "the turning of the wheel of the good law" (dharma-cakra-pravartana) has become a synonym for the Buddha's first proclamation of his doctrine, by which the thousand-spoked sun-wheel of righteousness was set in motion, radiating its light all through the world. Thus, the Buddha himself was a cakravartin, although not in the ordinary

sense, but as one who has conquered the world within himself by realizing the highest possibilities of his being in the thousandfold cakra of his mind (sahasrāra-cakra). The

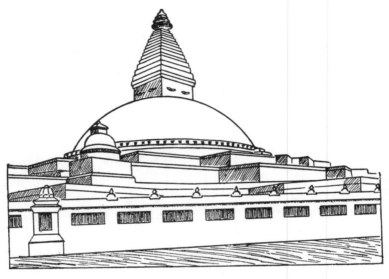

Figure 20

NEPALESE STŪPA: BUDDHANĀTHA CAITYA NEAR KATHMANDU

This stūpa is said to have been built in the times of King Mahā-deva in the 6th century A.D. The originally quadrangular ter-races of the substructure have become intricate patterns of cubic forms; the cupola, however, has retained the flat shape of the prehis-toric tumulus and of the archaic stūpa. The altar-like harmikā has been fused with the multi-storied spire, representing the Tree of Life, which here takes the form of a pyramid, crowned by a threefold umbrella. This shows that the umbrella origin of the steps of the pyramidal spires was no more remembered and completely replaced by the tree-symbolism and its transcendental world-planes. The eyes of the harmikā indicate the psycho-cosmic parallelism of the human body, whose vital centers correspond to the different parts of the stūpa.

Buddha, therefore, rightly demanded that the remains of the Enlightened Ones and their true disciples should be treated with the same respect as those of a cakravartin.

The cakras, as radiating centers of psychic force, gave a new impetus to the interpretation of the human body as a cosmic manifestation. Not only was the spinal column compared to Mount Meru, the axis of the universe, and therefore called 'meru-daṇḍa', but the whole psycho-physical organism was explained in terms of solar and lunar forces, which, through fine channels—the so-called nāḍīs—moved up and down between the seven cakras which in their turn represented the elementary qualities of which the universe is built and of which the material elements are only the visible reflexes. The most important nāḍīs are: the 'median nerve', Suṣumṇā-nāḍī, (Tibetan: dbuma-tsa), running through the center of the spinal column, and two nāḍīs, Iḍā (Tibetan: kyangma-tsa) and Piṅgalā (Tibetan: roma-tsa), which coil round the 'median nerve' in opposite directions, the pale white-colored Iḍā starting from the left, and the red-colored Piṅgala from the right. Iḍā is the conductor of lunar or 'moon-like' (candra-svarūpa) forces which have the regenerative properties and the unity of undifferentiated subconscious life as represented by the latent creativeness of seed, egg, and semen, in which all chthonic telluric cults are centered. Piṅgala is the vehicle of solar forces (sūrya-svarūpa, 'sun-like') which have the properties of intellectual activity, representing the conscious, differentiated, individualized life. Individualization, however, if separating itself from its origin, is as death-spelling as knowledge severed from the sources of life. This is why wisdom and compassion (prajñā and karuṇā) must be united for the attainment

of liberation. And for the same reason, Piṅgalā, the solar energy, without the regenerating influence of Iḍā, the lunar energy, acts like a poison, while even the elixir of immortality (amṛita), to which the regenerating lunar energy is compared, has no value without the light of knowledge. But in the life of the ordinary individual this synthesis, which would stimulate the dormant faculties of the various psychic centers to a state of divine harmony and power, does not take place, because only the bodily discipline and mental concentration of yoga cause the latent lunar energies of the root-center (mūlādhāra-cakra) to rise from center to center until the 'thousand-petalled lotus' (as the sahasrāra-cakra is also called), the seat of latent solar energies, is reached, vitalized through this union and set free to permeate the whole physical and spiritual organism of the individual.

In the Tibetan treatise on the "Yoga of Psychic Heat" (gtum-mo)[1] we are told that when the solar vital force, which stands for the five aggregates (Tibetan: phung-po, Sanskrit: skandha) of conscious individuality, unites with the lunar vital force, which stands for the five elements of nature (symbolized by Earth, Water, Fire, Air, and Ether), and enters into the 'median nerve', the realization of enlightenment is gradually achieved. After explaining the karmic principles of the four chief psychic centers located in the solar plexus (manipūra), in the heart (anāhata), in the throat (viśuddha), and in the crown of the head (sahasrāra-cakra), the text goes on to say, "The

1. Translated by Lama Kazi Dawa-Samdup, edited and published by Dr. W. Y. Evans-Wentz in *Tibetan Yoga and Secret Doctrines*, pp. 200 ff.

'moon-fluid' in moving upward through the nerve-centers, awakens these karmic principles into activity, and the upper extremity of the median-nerve is set into overwhelming vibration (of a blissful nature). And thus is produced the invisible psychic protuberance on the crown of the head."[2] Thereupon, the upward flow of the lunar vital force becomes more intense and simultaneously the solar vital force "issues in an intensified manner from the crown of the head and flows downward till it permeates all the body."

The unity of body and mind and consequently the inclusion of the body into the spiritual training, so that the body actually participates in the highest experiences and achievements, has always been a characteristic of Buddhist psychology and meditative practice. While describing the four stages of absorption (jhāna), for instance, the Buddha in the 77th discourse of *Majjhima Nikāya* adds to the explanation of each of these fundamental stages of meditation: "And he (who has attained the first, second, or third degree of absorption) penetrates and permeates, fills and saturates his body with the bliss of unification and serenity, so that not even the smallest particle of his body remains unsaturated by this blissful experience."

Thus in early Buddhism, as well as in the later Tibetan yoga, bodily harmony was both the effect and the condition sine qua non of all higher spiritual attainments. In Tantric terminology: Liberation and enlightenment are attained by the reconciliation of solar and lunar forces,

2. We have already mentioned the symbolical protuberance on the head of the Buddha image and the corresponding symbol of the stūpa's spire, the Tree of Enlightenment.

which on the physical plane are the two kinds of vital energy, on the psychic plane the intellectual and the emotional consciousness, and on the spiritual, i.e., most sublimated plane, wisdom (prajñā) and compassion (karuṇā).

On the basis of this profound parallelism, transcendental ideas and psychic processes could be expressed by material equivalents, either in terms of the human body or in terms of colors and architectural forms. Thus the Buddha, when speaking about the four great elements (mahābhūta) or states of aggregation, distinguished in each case between a subjective and an objective aspect, i.e., the elementary qualities of matter in their vital forms, as represented by the organs and functions of the human body[3] and in their fundamental or abstract forms, as the solid, the fluid, the fiery, and the gaseous state of inorganic matter. The realization of the fundamental laws of the world process and of one's own nature through the observation of bodily functions plays an important role in the Buddhist system of meditation and is one of the four pillars of insight (sati-paṭṭhāna).[4]

By carrying on this tradition the same parallelism was

3. The following passage from *Majjhima Nikāya*, 28, may serve as an example: "What now is the 'heating element' (tejodhātu)? The heating element may be subjective or it may be objective. And what is the subjective heating element? The dependent properties which on one's own person and body are heating and radiating, as that whereby one is heated, consumed, scorched, whereby that which has been eaten, drunk, chewed, or tasted, is fully digested, or whatever other dependent properties which on one's own person and body are heating and radiating—this is called the subjective heating element."

4. The parallelism between psychic and bodily functions was outlined by the Buddha when defining consciousness in terms of nutrition.

established with respect to the psychic organism whose vital centers (cakras) were found to correspond to the elementary qualities of matter: the main vital center, 'root-support' (mūlādhāra-cakra), situated in the perineum at the base of the spinal column, representing the root of the Tree of Life[5] and corresponding to the element earth, the solid state; the navel-center (maṇipūra-cakra) to the element water, the fluid state; the heart-center (anāhata-cakra) to the element fire, the heating or radiating state; the throat-center (viśuddha-cakra) to the element air, the gaseous state; the center on the crown of the head (sahasrāra-cakra) to the element ether, (or in its passive aspect, space), the state of vibration.

Each of these elements is symbolized by a sound (bīja-mantra, a mystic syllable of creative power), a color, and a basic form. The latter two are of special interest to us, as they have been directly applied to the stūpa architecture. Earth is represented by a yellow cube; water by a white sphere or a white round pot; fire by a triangular body of either round or square base, i.e., a cone or less frequent-

5. Mount Meru and the Tree of Life have become identical in the course of time; in fact, the whole Meru was imagined to have the form of a mighty tree, composed of many stories of circular terraces, comparable to the rings of a stūpa's conical spire. In the Tibetan treatise on the "Yoga of Psychic Heat" we are told that the "median-nerve (suṣumṇā) in its perpendicular straightness symbolizes the trunk of the Tree of Life" from which the various *cakras* branch out and open up like blossoms. From each *cakra* a great number of subsidiary psychic nerves radiate upwards and downwards, "appearing like the ribs of a parasol or like the spokes in the wheel of a chariot." This passage again shows the close symbolical relationship between parasol, wheel, lotus (padma is another name applied to psychic centers), and tree, all of which are related to the sun.

ly a pyramid; air is represented two-dimensionally as a semi-circular bow-shaped form of green color, three-dimensionally as a hemisphere with the base upwards like a cup; ether, which is graphically represented by a small acuminated circle or a blue dot (bindu), takes the three-dimensional form of a multi-colored, flaming jewel, i.e., a small sphere from which a flame emerges.

The Psycho-cosmic Principles of the Chorten

If we put all the above elements together in due order, namely, the sphere upon the cube, a cone or a pyramid upon the sphere, and upon the cone or pyramid a cup-like hemisphere which carries a drop-like body on its plane surface, we get the following figure (19) which represents the basic principles of the later stūpa architecture prevalent in the northern countries of Buddhism. The Japanese Shingon sect, which has most faithfully preserved the tradition of the Indian Mantrayāna, actually builds stūpas (sotoba) of exactly this shape as monuments for the dead. The Tibetan chorten also comes near to this ideal form, because the central cupola (aṇḍa) of the stūpa has been reversed into a pot-shaped vessel (Tibetan: bumpa) which rests on a cubic substructure and is crowned by a tall cone, ending in a small upturned hemisphere which carries on its plane surface a crescent, a sun-disc and the drop or flame-shaped 'jewel', one upon the other. In addition to this the main parts of the chorten are actually painted in the colors of the great elements (mahābhūta): the cubical substructure yellow (earth), the spherical central part white (water),

the conical spire red (fire), while the form of the fourth element (air), which should show a green surface, is generally hidden under the honorific umbrella, a symbol which, especially in its Tibetan form, is closely connected with the concept of air.

Without taking into account its tree origin and its natural relationship to sun, air, and sky, it may be mentioned that, according to later Indian and Tibetan tradition, honorific umbrellas were supposed to appear in the sky when a saint had realized certain magic powers, and that these umbrellas were, so to say, 'winged' with volants and loose flaps, moving up and down in the wind. These flaps or volants are not only applied to the honorific umbrellas which adorn the chorten but also to ceremonial umbrellas and canopies in Tibetan temples; and in pictorial representations of saints, sometimes numerous umbrellas with swaying volants can be seen hovering in the air. More important, however, for our present subject are the details of the crowning part of the spire of the Tibetan chorten. Between the horizontal umbrella-disc which covers the cup-like hemisphere and the flaming drop, symbols of air and ether respectively, there is a white crescent and a red sun-disc (the latter resting upon the inner curie of the crescent), which thus repeats the colors of the two main elements of the stūpa, namely that of the moon-related, waterpot-shaped central part and that of the sun-related spire. The meaning of this repetition becomes evident if we remember that the moon represents Iḍā (whose color is pale white), the sun, Piṅgalā (whose color is red), and the superimposed flaming drop, the synthesis of the solar and lunar energies in the Suṣumṇā and the final realization of enlightenment in the crown-center (sahasrāra).

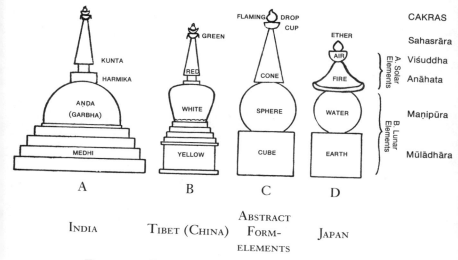

Figure 21 CAKRAS ACCORDING TO BUDDHIST TANTRA

A: Later stūpa-form with square terraces (medhi) and pinnacle of varying shape. Spire (kunta) sometimes pyramidal (see Nepal). B: Chorten (uppermost color not applied usually). C: According to Buddhist Tantra. D: Shingon Caitya (sotoba), Fire symbol of pyramidal shape.

In the spherical and conical parts of the chorten the two currents of psychic energy are represented by their separate and elementary aspects; in the crescent and the sun-disc they are represented in their sublimated or spiritualized form as knowledge (prajñā) and compassion (karuṇā), from the union of which the dazzling flame-jewel of perfect enlightenment is born. This symbol of unity and ultimate reality has its latent counterpart in the form of a blue dot (bindu) or seed (bīja), the creative spiritual element inherent in every sentient being as the potential consciousness of enlightenment (bodhicitta).

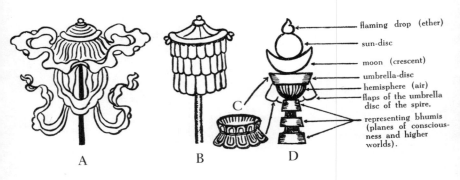

flaming drop (ether)

sun-disc

moon (crescent)

umbrella-disc

hemisphere (air)

flaps of the umbrella
disc of the spire,

representing bhumis
(planes of conscious-
ness and higher
worlds).

A

B

C

D

Figure 22

A: Flying umbrella (Tibetan style) with swaying volants, symbol of spiritual attainments. B: Tibetan ceremonial umbrella as used in temples and processions. C: Honorific umbrella of a chorten, taken off from the horizontal disc which forms its top part. D: Chorten.

The unfolding of this latent principle is the aim of the spiritual path, which is achieved when all our psychic faculties (as embodied in the various centers) are permeated by it. When the mystic union between the sun of knowledge and the moon of compassion has reached its zenith and consummation on the highest spiritual plane, the thousand-petalled lotus, then it happens that the dark seed, containing the essence of the universe and the ever-present reality of the dharma-dhātu, breaks open and bursts forth into the dazzling flame of enlightenment. The elementary significance of this flaming drop is, as we have mentioned already, ether or space. The Sanskrit term for it is 'ākāśa' (Tibetan: nam-mkhaḥ) for which there is no equivalent in any other language. It expresses the active and the passive aspect of the same elementary principle. The passive aspect consists in the notion of the absence of material

obstruction and is expressed in words like space and sky (in a secondary sense, heaven). The active aspect consists in the idea of an elementary vibration of point-like, infinitesimal units of invisible energy penetrating the whole universe. It is, as Sarat Chandra Das puts in his Tibetan Dictionary, "a metaphysical conception which may be expressed just like the point in geometry" (therefore the dot, the drop and the seed as symbolical equivalents). Thus ākāśa is all-pervading ether and all-containing space, the synthesis of all that exists, and therefore the symbol of the essential unity of cosmic, psychic, and physical energies, and of the philosophical conceptions of dharma-dhātu (positive aspect) and śūnyatā (negative, spatial aspect).

Just as both sun and moon are contained in space, which thus proves to be a unit of a higher order, so the solar and lunar tendencies are finally absorbed into a new spatial symbolism. This becomes evident even from the architectural point of view if we compare the stūpa-forms of the more orthodox type with those of Tibet. In the chorten, the hemisphere, which formerly represented the egg (aṇḍa) or the water-bubble—both forms of female fertility —has been transformed into the vessel with the elixir of life, the water of immortality (amṛita-kalaśa). In other words, the terrestrial water has been replaced by the celestial water; the symbol of female, latent fertility, has been replaced by that of male, active creativeness. The latter is identical with the 'moon-fluid', which is not only regarded as the fundamental principal of life, but also as the source of sympathetic and compassionate feeling which recognizes the oneness of all living beings and which, therefore, in the Tibetan yoga scriptures is directly called 'byang-chub-sems', the purified (byang) and perfected

(chub) mind (sems), i.e., potential bodhi-citta, the mind of a Bodhisattva. Thus, though a lunar principle again comes into the foreground, its nature is changed because it has turned from a terrestrial to a celestial-spatial direction, by discovering its close relationship to the complementary solar forces.

Architecturally this change is expressed in the fact that the hemispherical and bell-shaped stūpa-forms open themselves towards the earth while the vessel-shaped chorten opens towards the sky. In fact, the basis of the central or vessel-shaped part (Tibetan: bum-pa; Sanskrit: amṛita-kalaśa) of the chorten is narrower than its upper portion, while in the case of the orthodox stūpas the basis of the hemisphere or the bell is considerably wider than the upper parts of these forms. The contrast, which in this way can be observed between the earth-relatedness of the bell-shaped dāgoba and the sky-related chorten, should, however, not mislead us to interpret the latter in some sort of Gothic-transcendental sense. In spite of the vertical tendency of the chorten and its relationship to the higher planes of consciousness, popularly expressed as heavenly worlds, there is no parallel to the heavenwards-storming gothic attitude. The relationship to the higher worlds is not that of a passionate desire or of a violent dynamism, but a reflecting of higher realities on the material plane, comparable to the reflection of the sky in an open vessel. For the Buddhist the gaining of higher states of consciousness does not mean the violent breaking away from normal life or a denunciation of this world but the overcoming of illusory contrasts, knowing that the transcendental is immanent even in material forms which are symbols of that higher reality for which man has been striving since time immemorial.

Index